Welcome !

Welcome to The Lettering Workbook for Absolute Beginners, future hand letterer! Surely, you have a lot of questions about the art of lettering. "How do I get started?" "What tools do I need?" "What in the world is a baseline?" Not to worry! This book is here to answer any and all questions you may have. You'll find plenty of places to practice within the book, as well as a link to download extra practice pages.

You might be asking what hand lettering is, and there's a simple answer. Hand lettering is, simply put, the art of drawing letters. Hand lettering is used for everything from store signs to party invitations, from greeting cards to banquet menus. It's an incredibly versatile skill—and a fun one, at that!

There are a few varieties of this art, and many different styles, including calligraphy, mono-line, brush lettering—to name just a few! We'll get into the details of all the styles in a few pages.

Hand lettering can seem intimidating, with all the terms, techniques, and styles, but with enough practice, anybody can master this art. Whether your natural handwriting is excellent or not so much, you will take something away from this book and learn a new skill. This book is here to get you started on that path!

LET'S BEGIN OUR LETTERING JOURNEY !

ricca_garden

info@riccagarden.com

Published & Designed in Brisbane, Australia

First print: Jan 2022

FREE GOODIES

Are you in need of some more practice pages? Well, you're in luck! Since you picked up this book, you can get a link to download extra practice pages, lined paper, and more lettering goodies for your hand lettering journey! Just scan the QR code below or type riccagarden.com/lettering_workbook into your web browser. Then, provide your email, and you'll receive a link for additional practice pages!

SCAN HERE

HAPPY LETTERING!

TABLE OF CONTENTS

Everything You Need To Know To Get Started

Before we jump straight into the good stuff, there are a couple of things we need to clear up first. Remember those questions you have? Now would be a good time to bring those up. Get ready; there's a lot to go over! But don't let it overwhelm you. You can always refer back to these pages when you have a question.

Differences Between
Hand Lettering & Calligraphy

When you just get started, you might be wondering if there is actually a difference between hand lettering and calligraphy. Most of the time, these terms are used interchangeably when they are not actually interchangeable, there is definitely a difference!

Hand Lettering

Hand lettering is a form of writing in which letters are drawn rather than written. It's easier to learn and personalize, as you can adjust the style. Unlike in calligraphy, the rules for hand lettering are much more bendable, providing creative freedom. Many tools can be used in hand lettering.

Modern Calligraphy

As traditional calligraphy has evolved, modern calligraphy has emerged. In modern calligraphy, the rules are less strict, so you don't have to follow specific strokes to form a letter. The colors are typically more vibrant, and the style overall is more adaptable to the artist's individual tastes. Despite the name, brush lettering is, in fact, a form of modern calligraphy because it is being written rather than drawn.

Calligraphy

On the other hand, calligraphy is the art of writing. Traditional calligraphy is in a league all its own. Where hand lettering can be done with any medium, using any style or technique, traditional calligraphy is much more specific. It exclusively uses a dip pen, which has a metal tip on the end that is dipped into a container full of ink, called an inkwell. The rules and guidelines are stricter in calligraphy, and the letters are a bit more difficult to learn.

Examples of some traditional calligraphy styles include Copperplate, Spencerian, and Roman Capital. Traditional calligraphy won't be covered in this book, but it's a beautiful art and a great next step once you've mastered the art of hand lettering!

Introduction to Techniques and Styles

There are many techniques and styles in hand lettering. The beauty of this art is that the sky's the limit! You can use whatever you want, however you want—but there are some basics that are easy to start with and easy to build on. This is just an initial overview; all of the techniques and styles mentioned will be taught with greater detail later in the book!

Monoline

Monoline is consistent all the way through; all the lines are the same weight or thickness. It doesn't require much in terms of tools. It's usually used when a lot of other artistic elements are going to come into play, or when the letterer is looking for something minimalist.

Brush Lettering

Brush lettering is one of the more difficult techniques, but it's absolutely worth it. Brush lettering uses a specific tool called a brush pen. The pen flexes and bends, so the less pressure you put on it, the thinner the line. Conversely, more pressure gives you a thicker line.

Faux Calligraphy

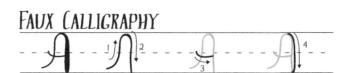

Faux calligraphy builds on both monoline and brush lettering. Faux calligraphy essentially mimics the look of brush lettering by writing in a monoline style and going back over the downstroke of the letters to add weight to the lines. Faux calligraphy has the look of brush lettering, but the technique is much easier to master.

Serif

Serif is a lettering style that adds a little bit of flair! Essentially, to make a serif style, you add some decorative strokes that extend off of the letter. It adds some variety, and it's very open for creative interpretation.

Sans Serif

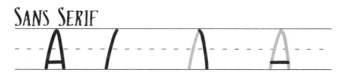

The word "sans" is a French word meaning "without." Yep, you guessed it--as compared to serif, sans serif is a lettering style that doesn't have any extra features at the end of the stroke. It is usually done in a simple and bold style, offering a youthful and modern look.

TERMINOLOGY

All the terminology may seem incredibly confusing if you don't know what you're talking about, but luckily, that's what this book is here for! Keep a bookmark here so you can refer back to this section quickly as needed.

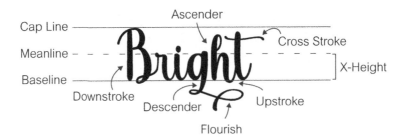

In lettering, there are a few basic lines that come into play. They help keep your letters consistent and in the right places. Think of the lines you used if you learned cursive in school--they're similar to those.

BASELINE: This is the line that all of your letters rest on. This line keeps them all in place, so you don't have a word that slowly creeps further down the paper.

MEANLINE: This is the middle line. This is usually where the top of your lowercase letters will be, so lowercase stays between the baseline and the meanline.

X-HEIGHT: This is how tall the lowercase letter x is. It is used to refer to the distance between the baseline and the meanline.

Moving past line definitions, there are some terms referring to specific parts of a letter or strokes of the pen.

ASCENDER: An ascender is any part of a letter that comes past the meanline.

DESCENDER: A descender is any part of a letter that extends past the baseline.

DOWNSTROKE: The downstroke is a pen motion. Any time the pen is writing in a downward motion, it's referred to as a downstroke. The downstroke is almost always thick, with the exception of the monoline style of hand lettering.

UPSTROKE: Another pen motion, an upstroke is essentially the opposite of a downstroke. An upstroke is any time the pen writes in an upward motion. Upstrokes are always thin.

CROSS STROKE: The cross stroke is the horizontal stroke used to connect or complete letters. The cross bar of the t is an example.

FLOURISH: A flourish is a very popular lettering stroke. It's essentially a blanket term for embellishing or decorating a letter. All the extra pen strokes and swirls to be seen in lettering are a flourish. The swirls on the letter g are an example of a flourish.

LETTERFORM: The letterform refers to a letter's basic shape.

TOOLS

There is seemingly no end to the sheer number of tools you could use to hand letter. You could use virtually anything, but there are some tools that work better than others. You don't need anything fancy or expensive when you're learning; starting with a basic pencil, markers, and a piece of paper is plenty!

PENCILS: Pencils are a good sketching tool, and a good way to add lines to guide the letters. They're great for putting down ideas before making them permanent. Pencils are great for beginners!

PENS: There are many different types of pens, so their main quality is how diverse they are. Pens are great for any lettering you want to do, and especially helpful for beginners. Micron pens are some of the best for lettering, as well as any sort of gel pens.

MARKERS: Markers are another staple for lettering, again because of their diversity. Using colored markers can elevate a lettered word instantly. They're best for any lettering at all, and for beginners. Crayola markers are cheap, good quality, and great lettering options.

BRUSH PENS: Brush pens are specifically for brush lettering because of their flexible structure. The Tombow Fudenosuke brush pens are an excellent option.

WATERCOLORS: There are several different forms of watercolors to use, such as a watercolor palette or watercolor pens. They work well for bigger lettering projects where lines are thicker or adding decorations and backgrounds.

CHALKS: Chalks are used most often when creating signs for a business or special occasion. They mostly are used on chalkboards, although experimenting with chalk on paper could be a fun project!

DIP PENS & INKWELL: These are what you use for true calligraphy. They're a bit more advanced, and not the best for a beginner. The pen has a metal nib with capillaries that draw ink in when dipped in the inkwell.

PAPER: The paper you use should be smooth so as not to damage your brush pen. Some great options are the HP premium 32 paper, the Rhodia pad, or the Canson XL marker pad. Tracing paper is also a useful tool to have on hand, to trace designs or letters for extra practice, or transferring designs.

RULER: A ruler is a great tool to have for making everything consistent! Use it to draw guidelines in pencil, and erase once the lettering is done.

Tool Reference Chart

If you need to know what tools are best for a specific style or skill level, this chart is a helpful guide!

TOOLS	SKILL LEVEL	WHEN TO USE	MESS LEVEL	HOW LONG IT TAKES TO LEARN
Pencils	Beginner	Use when tracing, sketching, first drafts, can also be used for practicing faux calligraphy	Minimal mess, easy to fix mistakes with an eraser	Requires little learning time, easy to pick up
Pens	Beginner	Use for monoline lettering and faux calligraphy	Minimal but can be messy when you have a pen that accumulates ink around the writing tip. Try to pick a pen with fast-drying ink to prevent smudging and smearing.	Requires little learning time, easy to pick up
Markers	Beginner to moderate	Use for monoline lettering, faux calligraphy, decorative additions	Can be fairly messy, especially when you are using alcohol based markers such as Sharpies and Copic Markers. They are great tools but they tend to bleed through the page.	Requires little to moderate learning time, depending on the style you want to achieve. You will need to select your markers carefully if you are trying to get small clean lines.
Brush Pens	Moderate to difficult	Use for brush lettering	Clean and precise, but mistakes can't be covered easily	There is a learning curve in controlling the line weight, which can require lots of practice
Watercolors	Difficult	Use for all styles, decorative additions	Very messy, but mistakes can be covered	Requires lots of learning time, lots of practice
Chalks	Beginner to moderate	Use for monoline lettering and faux calligraphy, generally when making signs	Chalk residue and dust can be messy, but mistakes can be easily erased with a damped towel or cotton swab	Requires little to moderate learning time
Dip Pens	Difficult	Use for calligraphy	Loose ink makes this tool very messy, mistakes can't be covered	Requires lots of learning time, very difficult to master

Position & Posture

You might be thinking that lettering would be a good pastime to work on while hunched over on the couch...think again! Your posture, position, the way you hold your pen, where your arm is, they all play an important part in your lettering.

First, lettering is best done at a desk. Start by sitting upright in your chair, with both feet flat on the floor. You don't want to be ruler-straight and stiff, but good posture should be kept in mind. Keep your shoulders back, and your head relatively up. A good rule of thumb is to bend without hunching.

Now, for the grip. Hold your tool in between your thumb and index finger, resting it on your middle finger. Make sure that you're holding your pen at a 45-degree angle to the page. You should be keeping your grip fairly loose, and remember that your fingers are just supporting the lettering instrument and keeping it steady, your arm does most of the moving. Keep in mind that grips can work differently between tools and people, so you might need to do some adjusting, but this is a good starting point!

Tips to Remember

1. Slow Down!

It's important to take your time when you're lettering. Going slowly is crucial to making clean and consistent lines. Position yourself in a comfortable way, and be patient.

2. Pick Up Your Pen

Something to remember when lettering is that the pen doesn't flow all the way through the word, like in cursive. After every stroke, whether an upstroke or downstroke, you should pick up your pen. This helps every line look the best that it can, elevating the look of your entire word.

3. Spacing

Spacing is really important in lettering. The space between every letter has to be consistent to keep things looking clean and neat. You can use a ruler to create guidelines and ensure the letters are uniform. When you've built up some skills, spacing is something you can experiment a little with as well!

4. Left-handed Lettering

There are a couple of ways to make left-handed lettering easier. First, find a grip that works for you. Experiment with different ways to hold your tools until you find one that's comfortable and functional. Another tip is to place tracing paper under your hand while you letter to avoid smudging. You could also take time to allow the ink to dry in between letters. Some pens and markers dry faster than others, so experiment with different tools to find what works best. A final tip: experiment with the placement of your paper! There's no rule that says you have to letter with the paper placed a certain way. It may be easier for you to rotate your paper, so go for it!

5. Developing Your Style

Most people have their own style of lettering, with tons of variations. The best way to develop your own style is to first get the basics down. Make sure you can consistently letter in the basic style before moving on--then experiment! You can try adding your own signature flourish, slanting your letters differently, writing a letter in a new way, using new tools for unique line weights--the list is endless! Just keep trying new things until you find something you really like, then start doing it every time you letter! Pretty soon, you'll have your own signature style.

6. Patience & Perseverance

Be kind to yourself! It's going to take time and practice. Don't get discouraged just because it doesn't look perfect on the first try--or the second or the tenth. A good way to keep from getting frustrated is to save all your practice sheets. When you've been at this a while, pull out the practice sheets you used the first time you lettered. Comparing where you started to where you are now is really helpful and encouraging! Most importantly, don't give up!

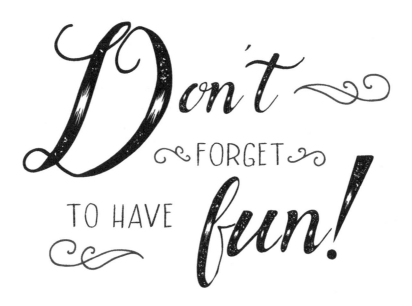

Don't FORGET TO HAVE fun!

Monoline

Monoline is one of the simplest styles of lettering. It's drawn in a consistent line with no weight variation. Best paired with bolder styles, it's used commonly on signs, logos, and other advertising items. Since the lines are so simple, other embellishments are often used to add interesting details. Monoline lettering also provides a good base for learning all the other lettering styles, so make sure to master this style before moving on!

The best tool to use for monoline lettering is a stiff drawing tool that can give you a consistent line. Pens, pencils, and stiff markers are the ideal choices.

Aa Bb Cc Dd Ee Ff
Gg Hh Ii Jj Kk Ll
Mm Nn Oo Pp Qg Rr
Ss Tt Uu Vv Ww Xx
Yy Zz

To start learning how to monoline, simply trace over the practice pages, following the direction of the arrows. You can experiment with any stiff tool, trying whatever line weight you'd like. The most crucial thing is to get a consistent line. After every stroke, pick up your tool and start the new line from where the last ended--and most importantly, take your time!

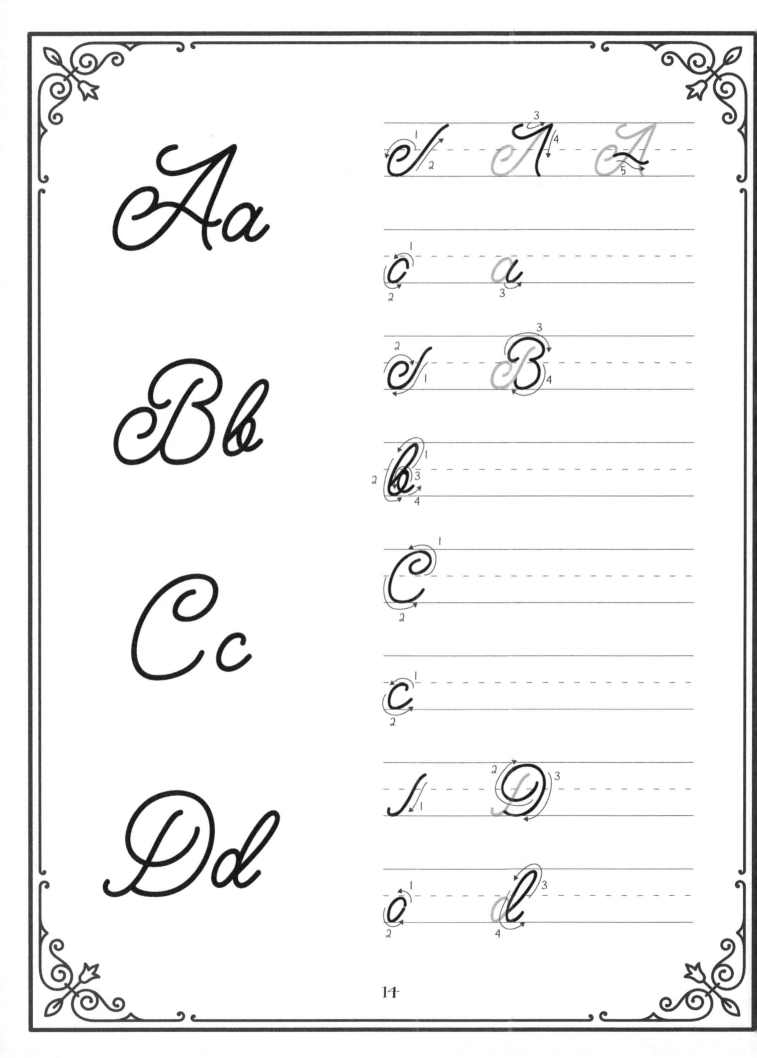

Aa Aa Aa Aa Aa Aa

Aa

Bb Bb Bb Bb Bb Bb

Bb

Cc Cc Cc Cc Cc Cc

Cc

Dd Dd Dd Dd Dd Dd

Dd

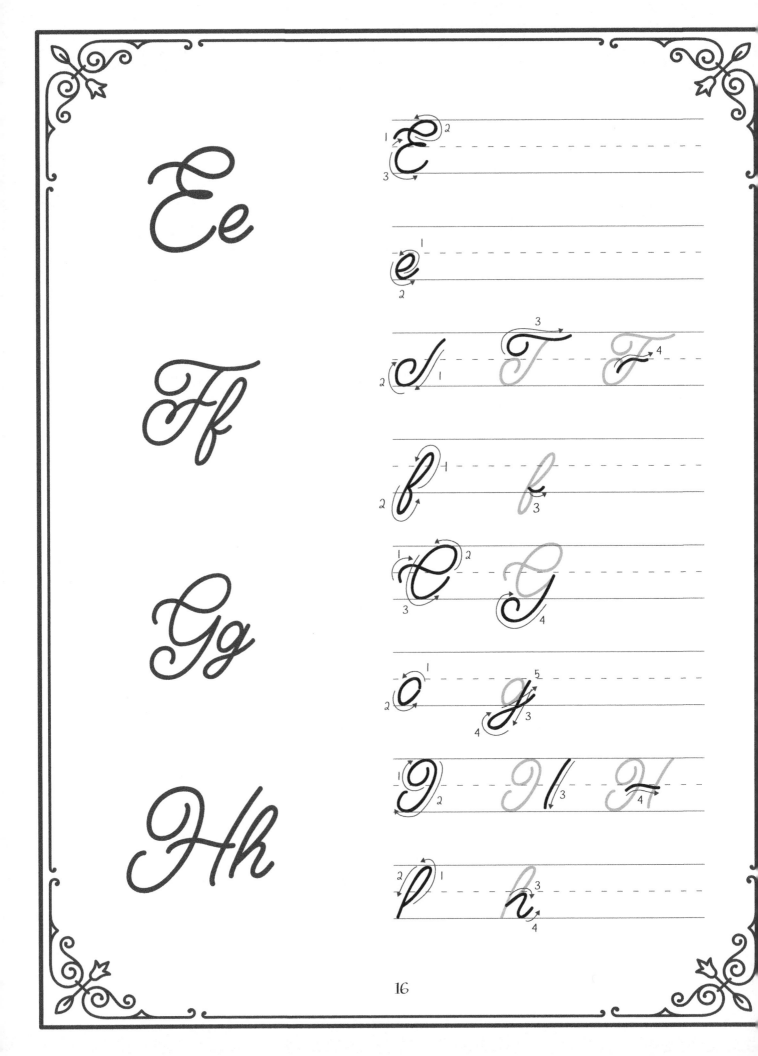

Ee Ee Ee Ee Ee Ee

Ee

Ff Ff Ff Ff Ff Ff

Ff

Gg Gg Gg Gg Gg

Gg

Hh Hh Hh Hh Hh

Hh

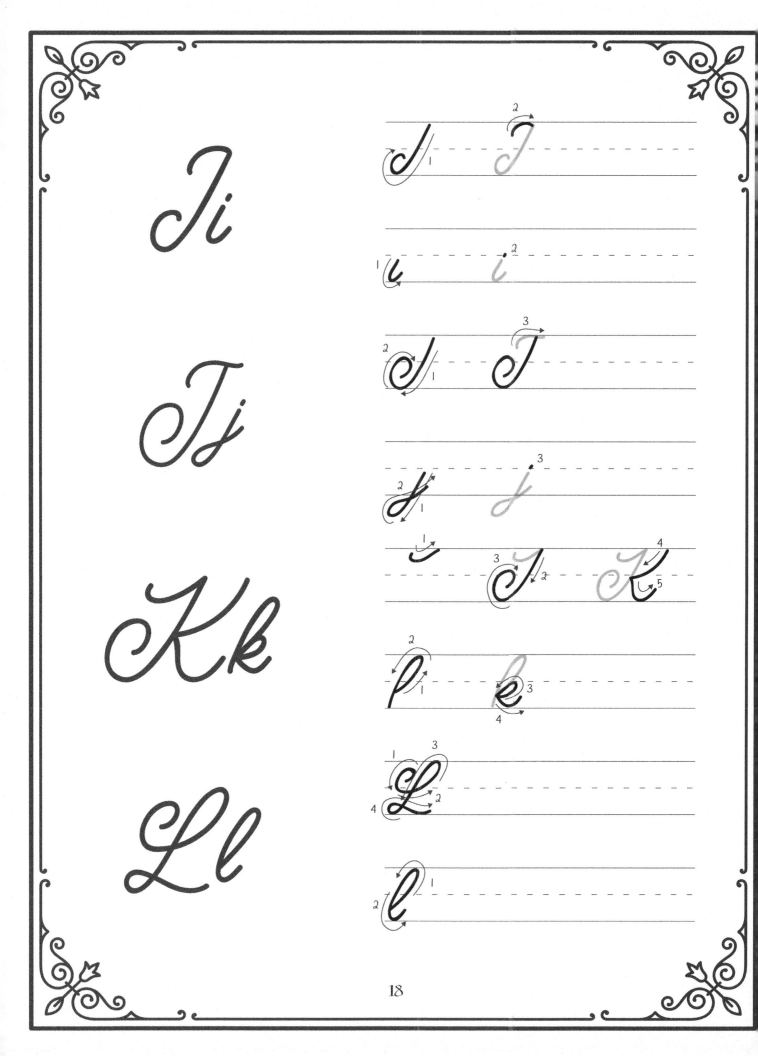

Ii Ii Ii Ii Ii Ii

Ii

Jj Jj Jj Jj Jj Jj

Jj

Kk Kk Kk Kk Kk

Kk

Ll Ll Ll Ll Ll Ll

Ll

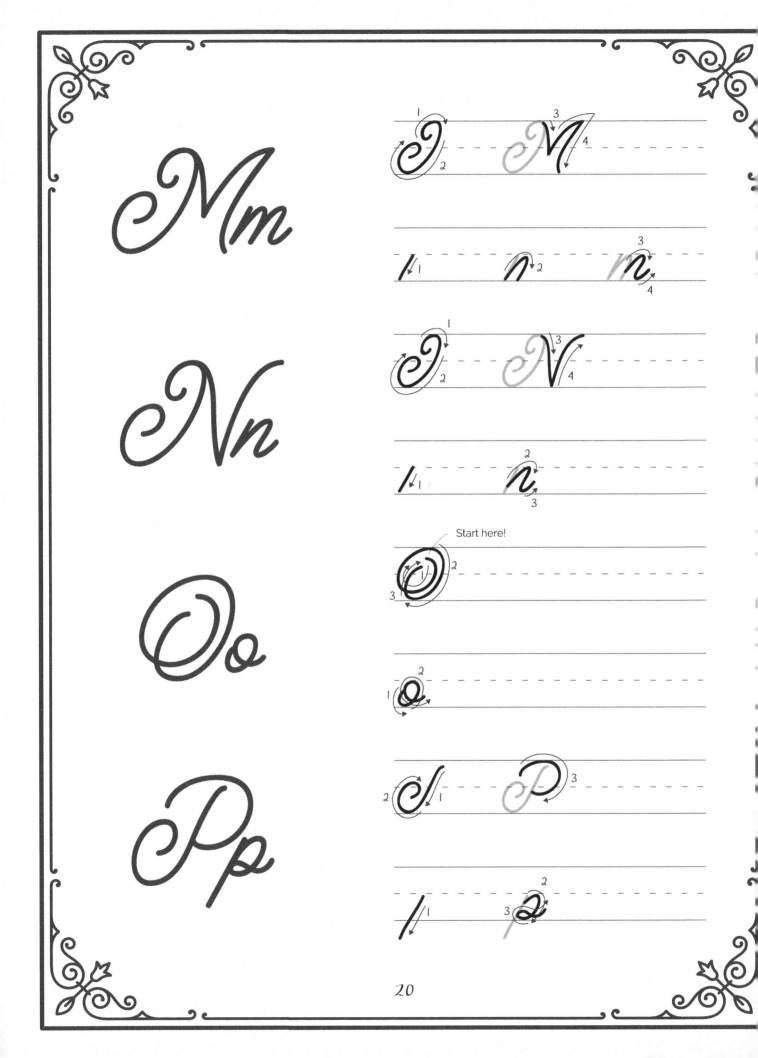

Start here!

Mm Mm Mm Mm Mm

Mm

Nn Nn Nn Nn Nn

Nn

Oo Oo Oo Oo Oo Oo Oo

Oo

Pp Pp Pp Pp Pp Pp

Pp

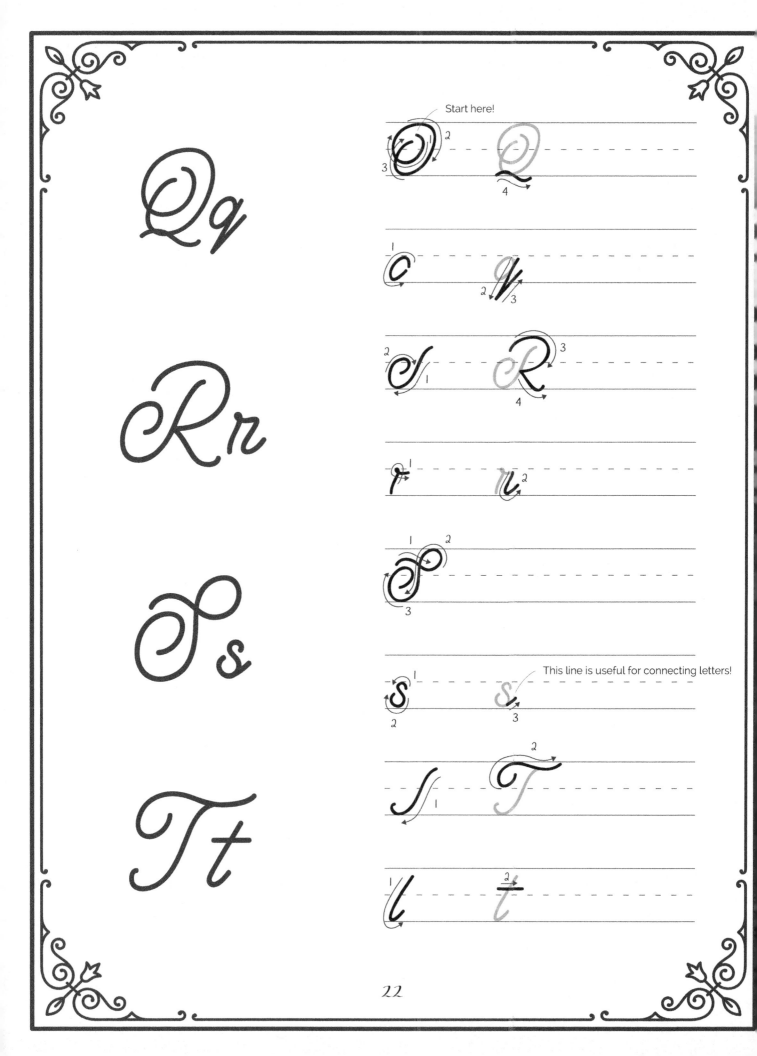

Start here!

This line is useful for connecting letters!

Qq Qq Qq Qq Qq Qq Qq

Qq

Rr Rr Rr Rr Rr Rr

Rr

Ss Ss Ss Ss Ss Ss

Ss

Tt Tt Tt Tt Tt Tt

Tt

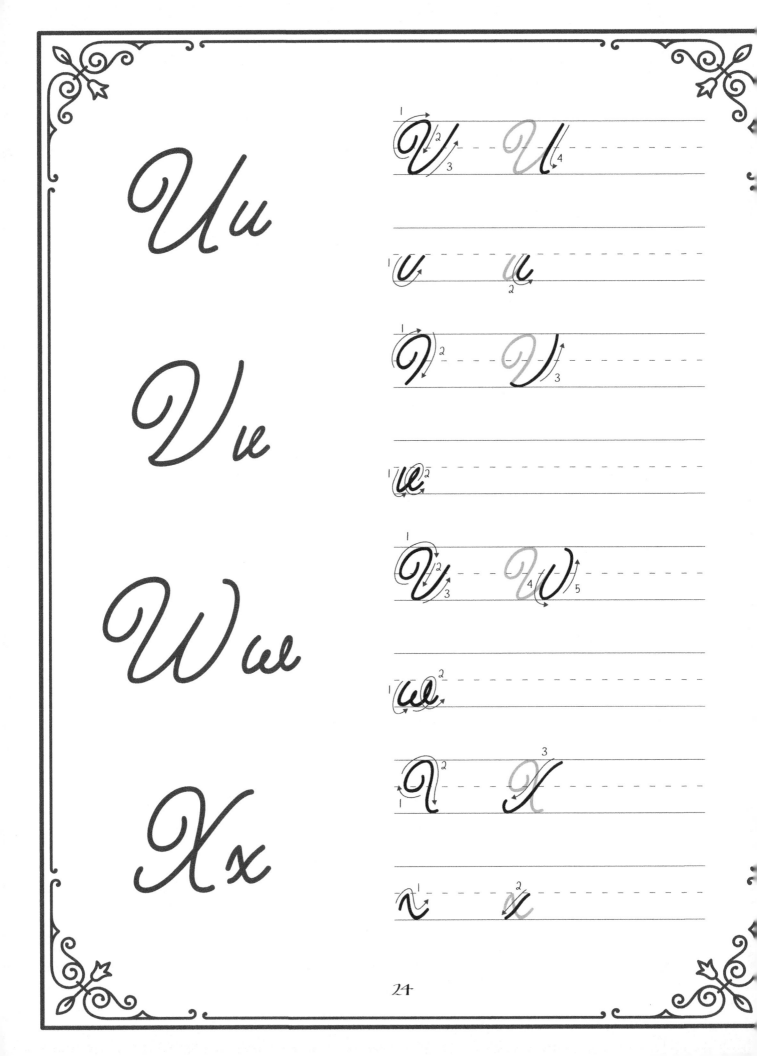

Uu Uu Uu Uu Uu Uu

Uu

Vv Vv Vv Vv Vv Vv

Vv

Ww Ww Ww Ww Ww

Ww

Xx Xx Xx Xx Xx Xx

Xx

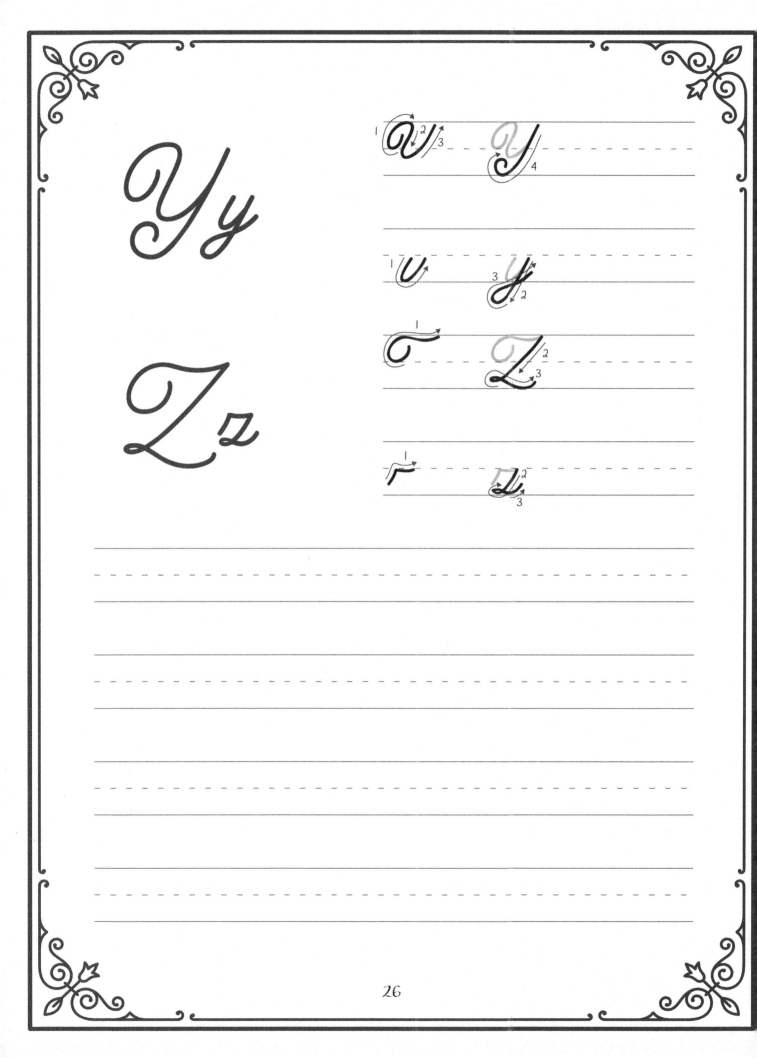

Yy Yy Yy Yy Yy Yy

Yy

Zz Zz Zz Zz Zz

Zz

PRACTICE HERE!

Faux Calligraphy

Faux calligraphy is a lettering style that's created just how it sounds; it's fake calligraphy! This is a way to achieve the beauty of calligraphy without the time-consuming work of trying to learn the rules and tools. This style of lettering is generally very flowy and similar in looks to both cursive and calligraphy. It's one of the most commonly used lettering styles because of its diversity. You can use virtually any tool, on any surface! Anything from glass to wood to fabric--it's all fair game.

The best tools for faux calligraphy are pens and markers. However, you can also start practicing with a pencil! Most other tools can also be used, but these are the easiest to begin with.

Aa Bb Cc Dd Ee Ff
Gg Hh Ii Jj Kk Ll
Mm Nn Oo Pp Qq Rr
Ss Tt Uu Vv Ww Xx
Yy Zz

How Faux Calligraphy Is Done

We'll start off explaining how to write it with the letter a as an example.

If you choose to fill in the space in between lines, use a tool with a thicker tip. If you leave the space open, a thinner, more precise option will be easier.

Cap Line

Meanline

Baseline

- Start at **1** and draw an open oval shape in between the meanline and the baseline. Draw back up slightly once you reach the baseline and stop underneath the start of the line. Lift your pen.

- Starting at **3** and connect a "u" shape to the oval, making an a. Congratulations, you've done the first part!

- Now, to make the letter an official faux calligraphy letter: going back to the oval shape, start at **4**. Add weight by drawing another line next to the first, with the pen moving downwards. Do the same thing starting at **5** and add weight to the existing line.

- You can leave the blank space between the lines open or fill it in. Look at that! You have a faux calligraphy a!

Faux Calligraphy Basic Strokes

Before we get to drawing full letters, practicing the basic strokes on their own is the best way to become familiar with this lettering style. When practicing, always start with your pen at 1, and follow the direction of the arrows. Keep in mind, whenever the pen is moving downwards, that's a downstroke, and you'll be thickening that stroke. The practice pages leave the space between the lines open, so you can choose whether or not to fill it in.

Upstroke

Thicken the downstroke

Once you've become familiar with the basic strokes, it's time to start putting it all together! Follow the same directions to work on the alphabet, remember the tips discussed earlier, and be patient with yourself! Take as much time as you need to really master the faux calligraphy alphabet!

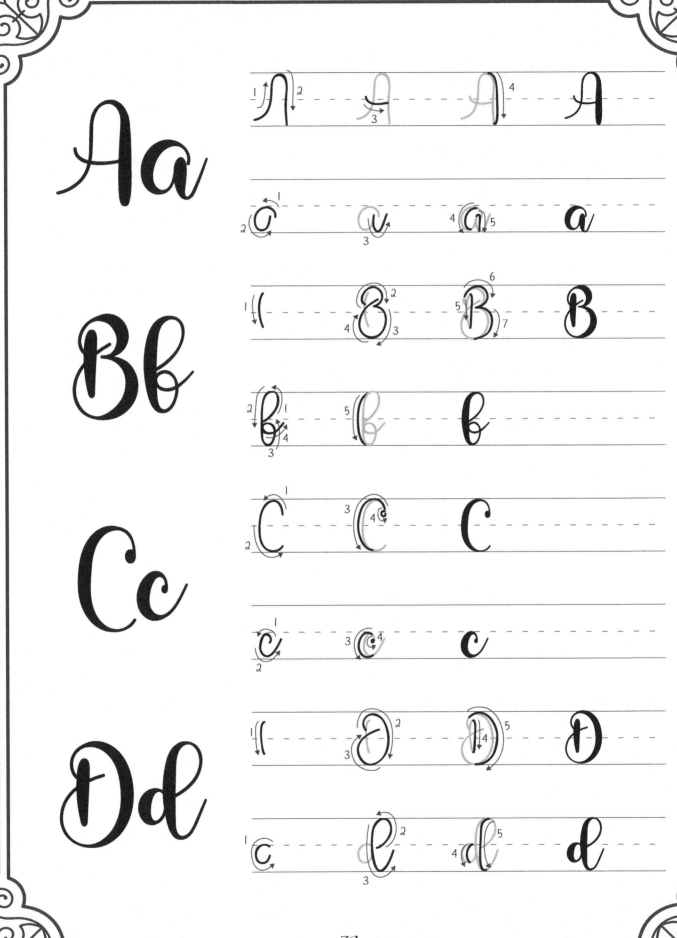

Aa Aa Aa Aa Aa Aa

Aa

Bb Bb Bb Bb Bb Bb

Bb

Cc Cc Cc Cc Cc Cc

Cc

Dd Dd Dd Dd Dd Dd

Dd

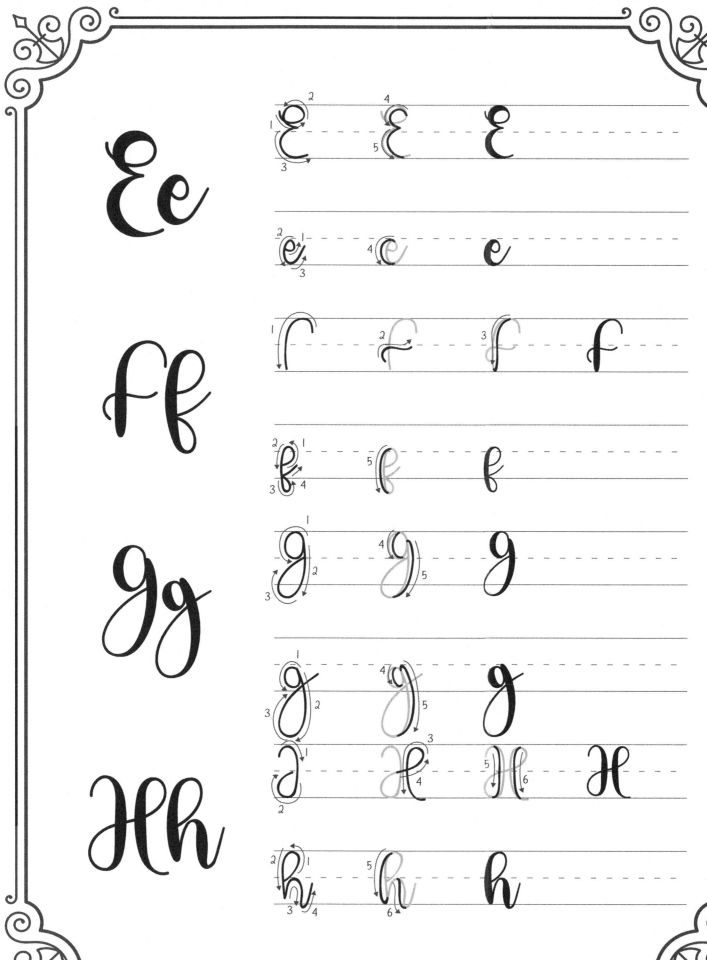

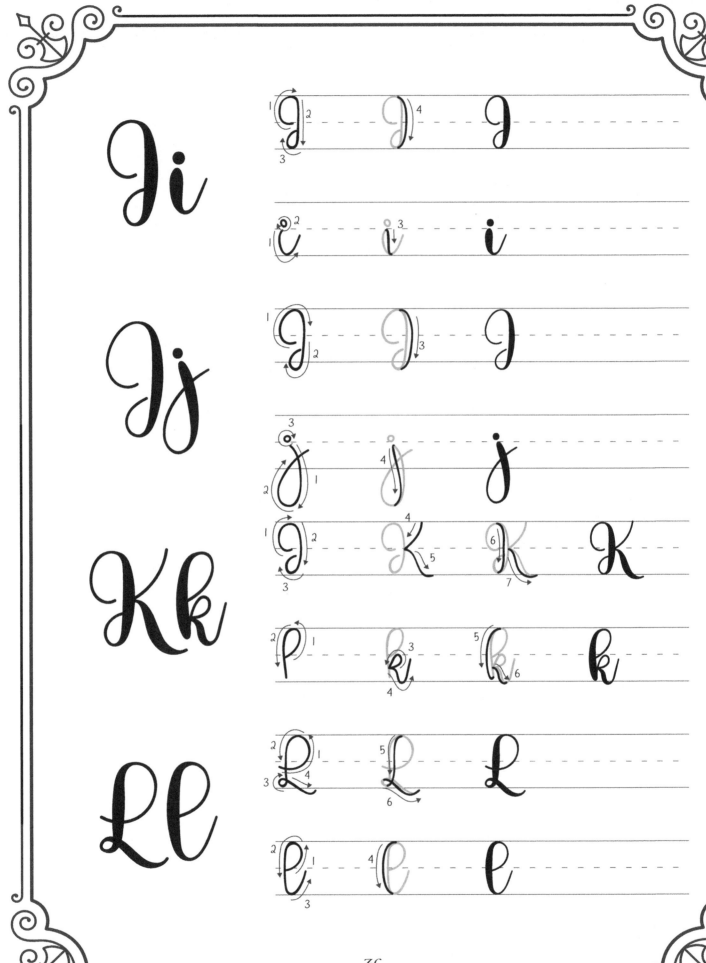

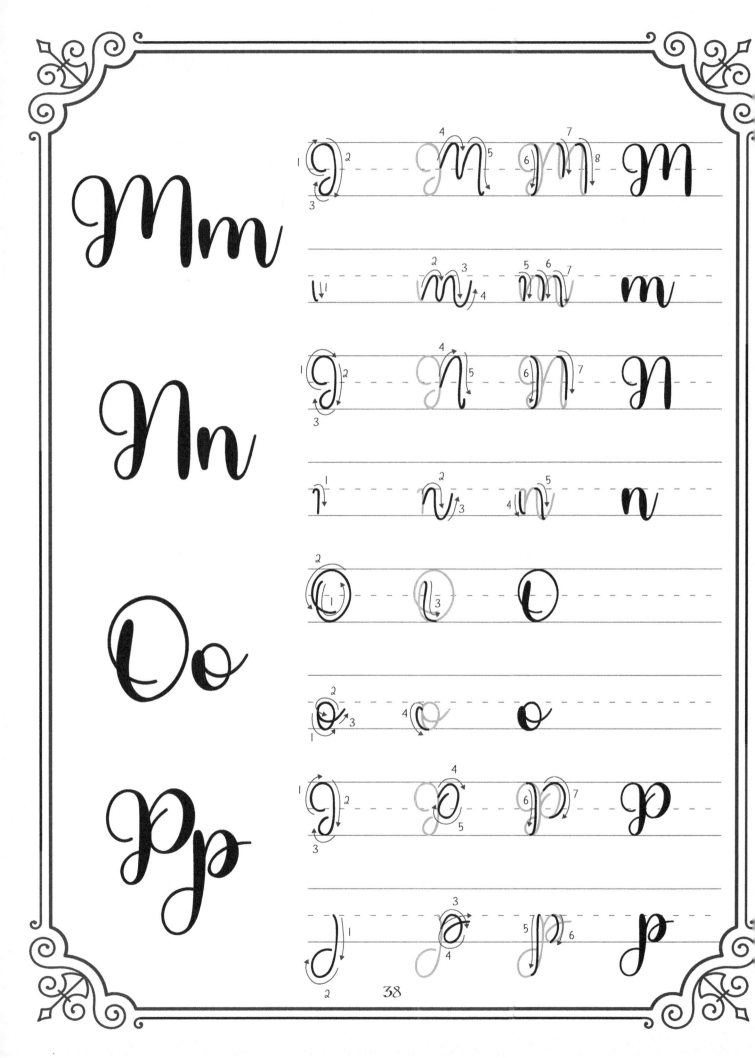

Mm

Nn

Oo

Pp

Mm Mm Mm Mm

Mm

Nn Nn Nn Nn Nn Nn

Nn

Oo Oo Oo Oo Oo Oo

Oo

Pp Pp Pp Pp Pp Pp

Pp

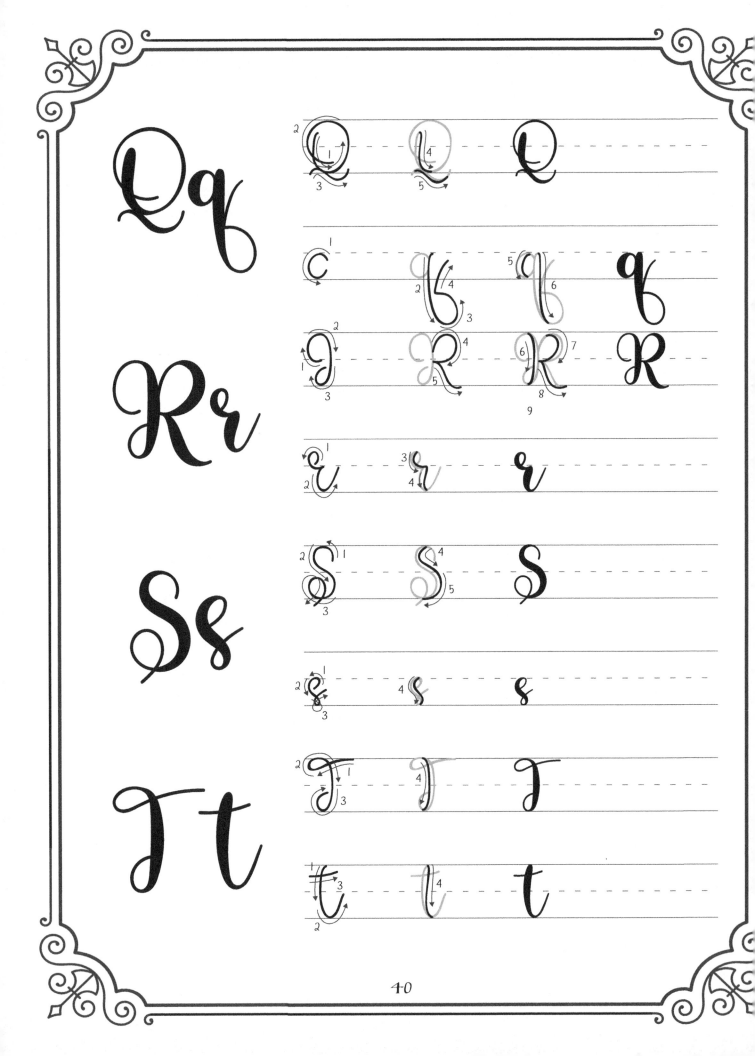

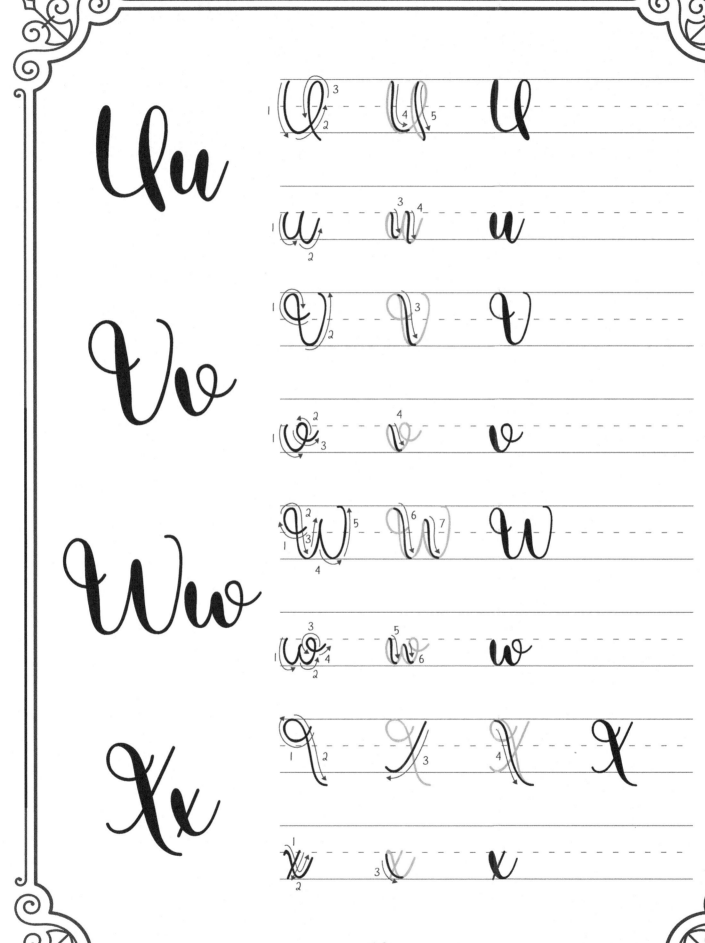

Uu Uu Uu Uu Uu Uu

Uu

Vv Vv Vv Vv Vv Vv

Vv

Ww Ww Ww Ww Ww

Ww

Xx Xx Xx Xx Xx Xx

Xx

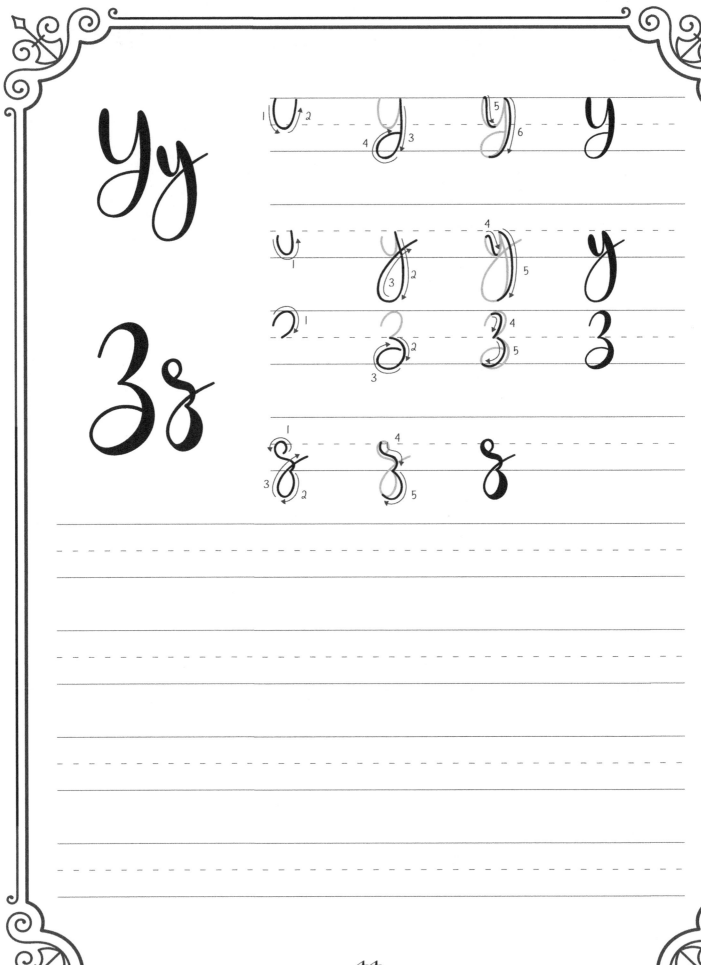

Yy Yy Yy Yy Yy Yy

Yy

3g 3g 3g 3g 3g 3g

3g

Brush Lettering

Brush lettering is where our practice gets a little bit more advanced. It will be helpful if you're familiar with monoline lettering and faux calligraphy before moving on to brush lettering, as you'll be building on the skills you learned with those styles. Brush lettering is commonly seen in more formal or fancy letterings, like wedding invitations or graduation announcements.

Brush lettering uses a specific technique to achieve line variation: increasing and decreasing pressure on the pen, rather than adding extra lines as in faux calligraphy. The pen is still lifted between strokes in order to gain better control over each individual letter and to stay consistent. Usually, a brush pen is used for the actual lettering. Paint and a flexible paintbrush could also be used, but these can be more difficult to work with.

Aa Bb Cc Dd Ee Ff
Gg Hh Ii Jj Kk Ll
Mm Nn Oo Pp Qq Rr
Ss Tt Uu Vv Ww Xx
Yy Zz

The 8 Basic Strokes

Upstroke

Start with your brush pen at the bottom, and draw a line upwards. Remember not to add pressure, so you can get a nice, thin line.

Downstroke

Using a similar technique, start at the top and draw a line down. This time, add pressure and push the brush pen down a bit more to make the line thicker. The more pressure, the thicker the line.

Overturn

Start at the bottom, drawing a curved upstroke. Without stopping, curve the line into a downstroke, adding pressure to get the thick line. This one is tricky, as you'll have to change pressures during the stroke itself. Go slowly and keep practicing!

Understroke

The underturn is the reverse of the overturn. Start at the top and draw a curved downstroke. Don't forget the pressure! At the bottom, release pressure and draw a curved upstroke. Remember to keep the pen moving through the whole stroke. Go slowly as needed, but not too slowly, as your hand may get shaky.

Compound Curve

The compound curve is a stroke commonly used when connecting letters. Remember that the pen doesn't leave the page and continues to move all the way through the stroke. Starting at the left, from the bottom, draw a curved upstroke. Draw a curved downstroke, then repeat an upstroke. Remember that the downstroke should be thick and the upstrokes thin, so you should end up with two thin lines and a thick one in the middle.

Oval

An oval is simply an elongated circle with line variations. Start at the top, and draw a curved downstroke. At the bottom, release pressure and draw a curved upstroke, and instead of ending it, curve it to connect back to the downstroke at the top.

Ascending Loop

The ascending loop is used on letters that come above the meanline, like h, b, d, and so on. To start, you're going to position your pen about halfway above where you want the stroke to end. Start a curved upstroke and make an oval-like shape. Then, keep the pen moving and finish the loop with a downstroke straight down. The ascending loop will almost always combine with another stroke to make a full letter.

Descending Loop

The descending loop follows the same basic idea as the ascending loop. It's also a stroke to finish off a letter, and the stroke always falls below the baseline. It accompanies letters such as g and y. It's also a stroke that flourishes commonly build on.

To start it, place your pen in the middle of where you want the stroke to be and draw a downstroke that curves at the end. Keep the pen moving, release pressure and draw a curved upstroke. You should end up with an oval-like closed shape.

ONCE YOU'VE BECOME FAMILIAR WITH THE DIFFERENT STROKES, MOVE ON TO PRACTICING ON THE NEXT FEW PAGES! IF YOU GET STUCK, YOU CAN COME BACK TO THE EXPLANATIONS.

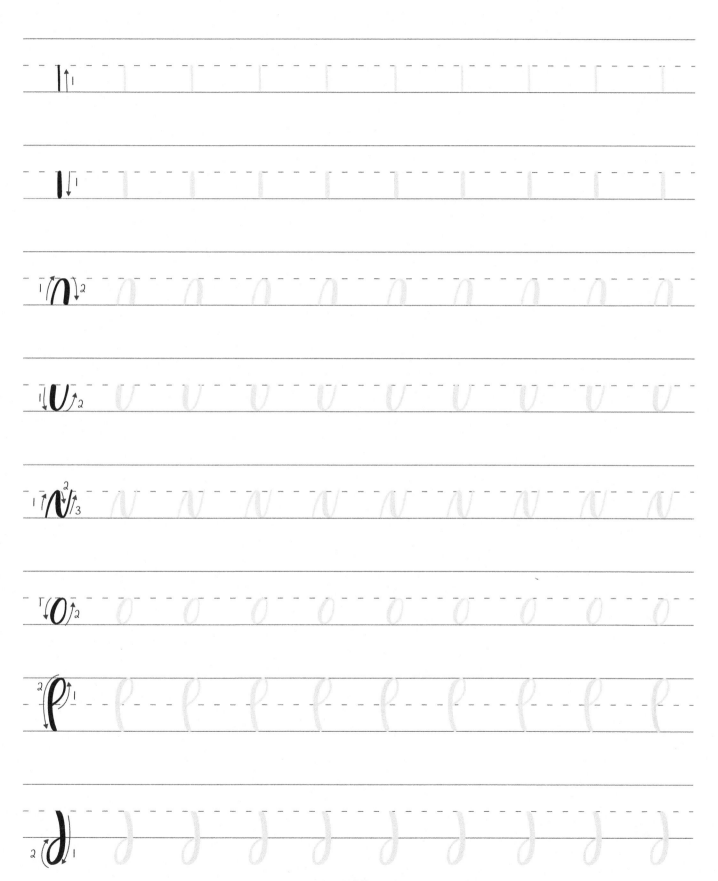

BASIC STROKES

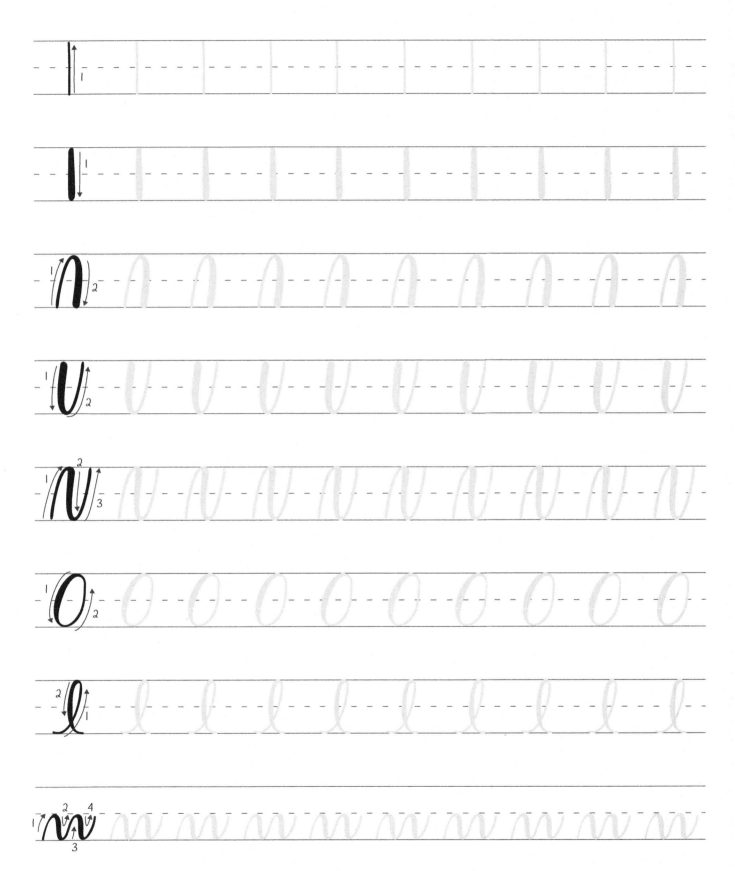

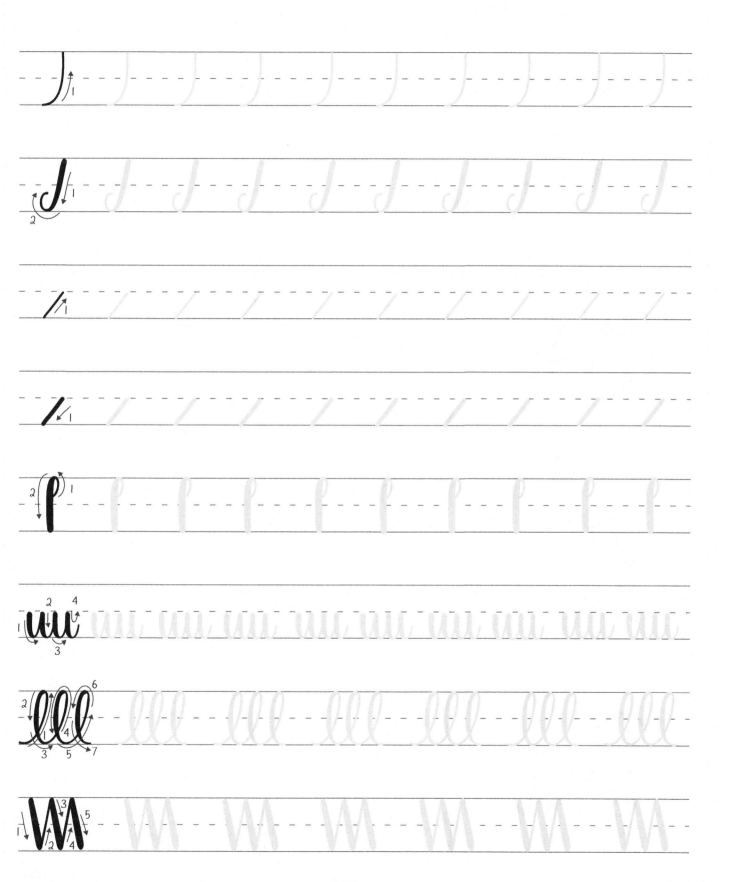

The brush lettering alphabet can be a bit more difficult. With so many different strokes, lines, and terms, it's overwhelming! This section is here to provide a little more clarity by guiding you through each letter.

Aa

Cap Line
Meanline
Baseline

Draw a downstroke from where the last stroke ended.

Draw an upstroke, curling it at the beginning.

Add a cross stroke.

Draw an oval, leaving it open at the top right.

Draw an underturn from where the oval shape started.

Bb

Draw a downstroke.

Starting from the top of the last stroke, draw two sideways overturns, curving them into the B shape.

Add a loop at the bottom.

Draw an ascending loop.

Draw a sideways overturn starting from the middle of the ascending loop.

Add a loop at the bottom of the stroke.

Cc

The C is very similar to the basic oval stroke, except you leave the oval opened.

Draw the lowercase c like the capital C, except do it between the mean line and baseline.

Dd

Draw a downstroke.

Starting from slightly outside of the last stroke, and draw a sideways overturn.

Add a loop at the bottom.

Draw an oval, leaving it open at the right.

Draw an ascending loop, connecting it to the open back of the previous stroke.

52

Aa Aa Aa Aa Aa Aa

Aa

Bb Bb Bb Bb Bb Bb

Bb

Cc Cc Cc Cc Cc Cc

Cc

Dd Dd Dd Dd Dd Dd

Dd

Ee

Cap Line — Meanline — Baseline

Draw a sideways underturn.

Starting from where the last stroke ended, connect another sideways underturn, making this one larger.

Draw a small ascending loop, keeping it below the meanline and bringing the tail up higher.

Ff

Draw a downstroke.

Draw a slightly curved cross bar at the cap line.

Add another cross bar at the meanline.

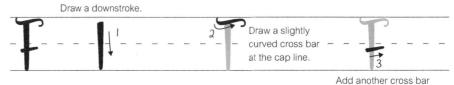

Add a small upstroke coming off the letter.

If you break down the lowercase "f" into basic strokes, you will first be drawing an ascending loop.

Starting from where the last stroke ended, draw a descending loop, closing the loop at the baseline. Practice connecting the two strokes without picking up your pen in between!

Gg

Draw a "C" shape.

Add a descending loop, starting from where the last stroke ended.

Draw an oval, leaving it open at the right.

Add a descending loop, starting from the top of the last stroke, bringing the tail up a little higher.

Hh

Draw a downstroke.

Add a cross stroke.

Repeat, spacing the lines slightly apart.

Draw an ascending loop.

Starting about halfway down the last stroke, draw a compound curve.

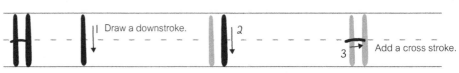

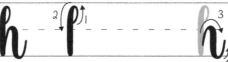
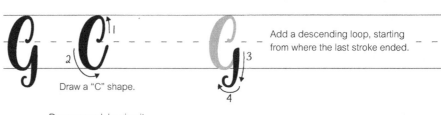

Ee Ee Ee Ee Ee Ee

Ee

Ff Ff Ff Ff Ff Ff

Ff

Gg Gg Gg Gg Gg Gg

Gg

Hh Hh Hh Hh Hh Hh

Hh

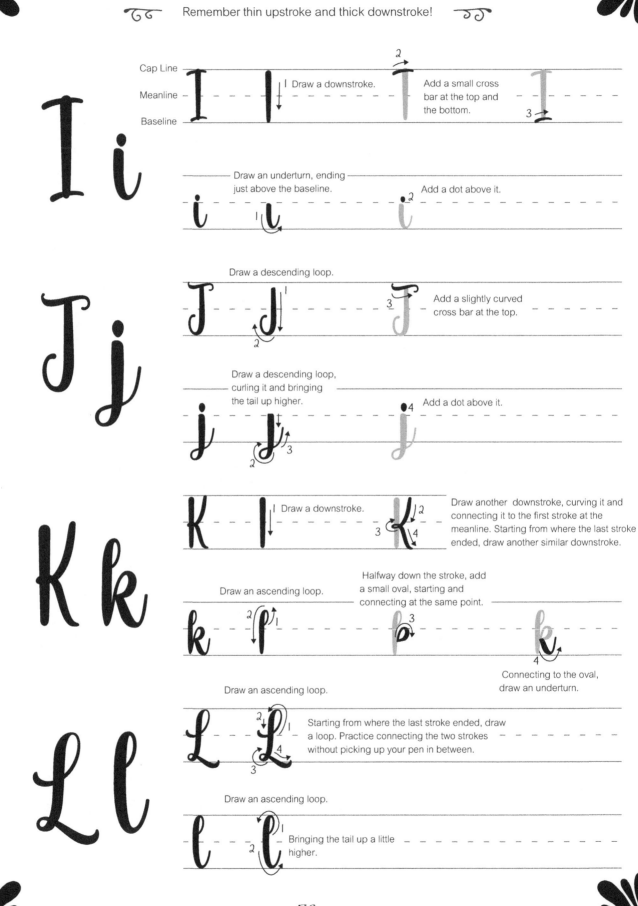

I i

Cap Line

Meanline

Baseline

Draw a downstroke.

Add a small cross bar at the top and the bottom.

Draw an underturn, ending just above the baseline.

Add a dot above it.

J j

Draw a descending loop.

Add a slightly curved cross bar at the top.

Draw a descending loop, curling it and bringing the tail up higher.

Add a dot above it.

K k

Draw a downstroke.

Draw another downstroke, curving it and connecting it to the first stroke at the meanline. Starting from where the last stroke ended, draw another similar downstroke.

L l

Draw an ascending loop.

Halfway down the stroke, add a small oval, starting and connecting at the same point.

Connecting to the oval, draw an underturn.

Draw an ascending loop.

Starting from where the last stroke ended, draw a loop. Practice connecting the two strokes without picking up your pen in between.

Draw an ascending loop.

Bringing the tail up a little higher.

Ii Ii Ii Ii Ii Ii

Ii

Jj Jj Jj Jj Jj Jj

Jj

Kk Kk Kk Kk Kk Kk

Kk

Ll Ll Ll Ll Ll Ll

Ll

Going back to the last stroke, draw a downstroke.

Cap Line

Meanline — Draw an upstroke, with a curl at the bottom.

Baseline

Starting from where the last stroke ended, draw a downstroke, then an upstroke.

Starting from halfway up the last stroke, draw a compound curve.

Draw a downstroke.

Starting from where the last stroke ended, draw an overturn.

Draw an upstroke, with a curl at the bottom.

Starting from where the last stroke ended, draw a downstroke.

Starting from the capline, draw a downstroke, connected to the end of the last stroke.

Draw a downstroke.

Starting from the bottom of the last stroke, draw a compound curve.

Draw an oval, adding a line at the end that goes partly through the middle of the letter.

Draw an oval, with a line that goes through the letter to the other side, curling it slightly at the end. You will find that line useful when you connect your letters together!

Draw a downstroke.

Starting from slightly outside of the last stroke, draw a sideways overturn, connecting it halfway down the last stroke.

Starting from the last stroke began, draw an overturn, connecting it halfway down the last stroke.

Draw a downstroke.

Add a loop coming out of the letter.

58

Mm Mm Mm Mm Mm Mm

Mm

Nn Nn Nn Nn Nn Nn

Nn

Oo Oo Oo Oo Oo Oo

Oo

Pp Pp Pp Pp Pp Pp

Pp

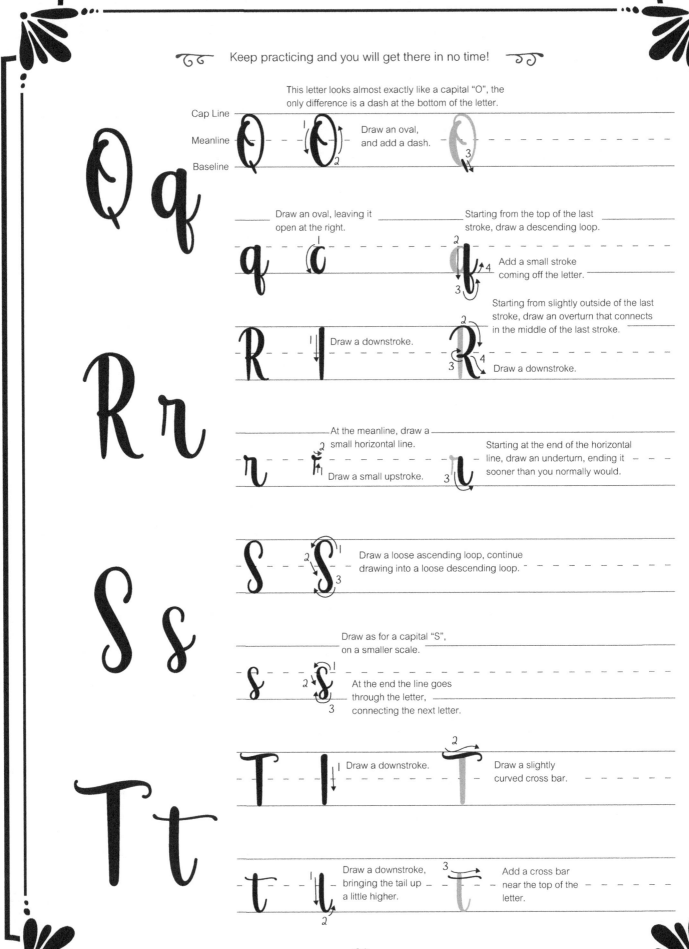

This letter looks almost exactly like a capital "O", the only difference is a dash at the bottom of the letter.

Cap Line
Meanline
Baseline

Draw an oval, and add a dash.

Draw an oval, leaving it open at the right.

Starting from the top of the last stroke, draw a descending loop.

Add a small stroke coming off the letter.

Draw a downstroke.

Starting from slightly outside of the last stroke, draw an overturn that connects in the middle of the last stroke.

Draw a downstroke.

At the meanline, draw a small horizontal line.

Draw a small upstroke.

Starting at the end of the horizontal line, draw an underturn, ending it sooner than you normally would.

Draw a loose ascending loop, continue drawing into a loose descending loop.

Draw as for a capital "S", on a smaller scale.

At the end the line goes through the letter, connecting the next letter.

Draw a downstroke.

Draw a slightly curved cross bar.

Draw a downstroke, bringing the tail up a little higher.

Add a cross bar near the top of the letter.

Qq Qq Qq Qq Qq Qq

Qq

Rr Rr Rr Rr Rr Rr

Rr

Ss Ss Ss Ss Ss Ss

Ss

Tt Tt Tt Tt Tt Tt

Tt

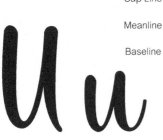

Cap Line

Meanline · · · · · · Draw an underturn. · · · · · · · · · 3 · Draw a downstroke,
connecting it to the underturn.

Baseline

Very similar to the capital "U", just draw it smaller and
bring the tail up a little higher.

Draw a slanted
downstroke. Starting at the end of the last
stroke, draw a slanted
upstroke.

Draw as for a capital "V", on a smaller scale
and adding a loop and a tail on the left side.

Draw an underturn,
ending it sooner than
you normally would. Connecting to the last,
draw another underturn.

Draw as for a
capital "W" in a
smaller scale. Add a loop at
the end.

Draw a slanted
downstroke. Starting at the baseline, draw an
upstroke slanting the opposite
way, crossing the first stroke at
the meanline.

Draw a curved
downstroke. Starting at the baseline, draw an
upstroke, slanted in the opposite
direction, crossing the first stroke
in the center.

Uu Uu Uu Uu Uu Uu

Uu

Vv Vv Vv Vv Vv Vv

Vv

Ww Ww Ww Ww Ww Ww

Ww

Xx Xx Xx Xx Xx Xx

Xx

Cap Line

Meanline

Baseline

Y y

Z z

Draw an underturn.

Starting from the end of the last stroke, draw a descending loop.

Draw an underturn.

Starting from the end of the last stroke, draw a descending loop, bringing the tail up a little higher.

Draw a horizontal line at the capline.

Draw a slanted downstroke connected to the last stroke.

Draw another horizontal line at the baseline.

Starting where the last stroke ended, draw a tail, adding a loop to it.

Draw an overturn.

Yy Yy Yy Yy Yy Yy Yy

Yy

Zz Zz Zz Zz Zz Zz Zz

Zz

PRACTICE HERE!

Connecting Letters

Now that you've become familiar with the alphabet on its own, it's time to move on to connecting the letters together.

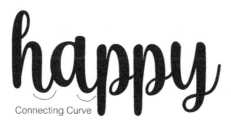

Connecting Curve

Using the word "happy" as an example, we can see a few key points when it comes to connecting letters. The letters should all connect in a similar way. The connecting curve of the **h** and the **a** are a similar length and shape and are found in the same general area of the letters. The spacing between letters should also be consistent; in the word "happy," all the letters are roughly the same distance from each other.

Many letters flow naturally into each other, but that's not always the case. Letters end and begin in different places: some on the meanline, others on the baseline--and some letters don't have a clear connection point. When that happens, try finding a few ways to connect the letter and pick your favorite. Here are a few examples:

Connecting O & M:

om om

Connecting E & R:

er er

Too many loopy connections should be avoided, as they can get confusing. As in the example below, it can become hard to tell which letter is which because of all the loops.

Connecting V & R:

vr ——Try these connections!——▶ *vr vr*

The last thing to remember is that you don't have to connect every letter. Sometimes, leaving them separate looks better, so try that too!

CONNECTING LETTERS

Use these next few pages for practicing some simple connections!

ah *ah* *ah*

du *du* *du*

fe *fe* *fe*

br *br* *br*

er *er* *er*

vr *vr* *vr*

yr *yr* *yr*

wr *wr* *wr*

ki ki ki

pe pe pe

ph ph ph

ox ox ox

ll ll ll

mm mm mm

nn nn nn

ss ss ss

Connecting Letters

Once you've gotten used to short connections, you can try these longer words for some more practice!

life life life

joy joy joy

love love love

hope hope hope

wish wish wish

kind kind kind

bless bless bless

vibes vibes vibes

peace peace peace

grace grace grace

sweet sweet sweet

dream dream dream

Connecting Letters

believe believe believe

bright bright bright

courage courage courage

summer summer summer

weekend --- weekend --- weekend

simplicity --- simplcity --- simplicity

christmas --- christmas --- christmas

beautiful --- beautiful --- beautiful

Flourishes

Flourishes are not easy to master, but they are well worth the effort. Flourishes are a great way to make a word look even more beautiful or make it stand out from other words. Flourishes can be as simple or as complex as you'd like; it's all up to you!

It might be beneficial for you to start practicing flourishes early. This way, by the time you're familiar with a few lettering styles, you can add flourishes right away!

When adding flourishes, as with all lettering, remember to keep your grip light. Move your whole arm rather than just your fingers, or your lines can get shaky--especially with bigger flourishes. As for the lines themselves, don't cross two thick lines, and don't try to pack too much into one small space.

There are five ideal spots to add flourishes.

Ascending Loops
on letters like b, d, f, h, k, and l

The End Of A Word

Descending Loops
on letters like f, g, j, p, y, and z

Underneath A Word

Cross Bars

🍃 Experimentation Is Always Encouraged! 🍃

These Are Just A Few Examples Of Easy Places To Put A Flourish!

The next few pages are for you to practice some different flourishes. To keep things simple, practice with a pencil or pen in a monoline style. As you become more comfortable, you can start creating line variations with a brush pen.

FLOURISHES

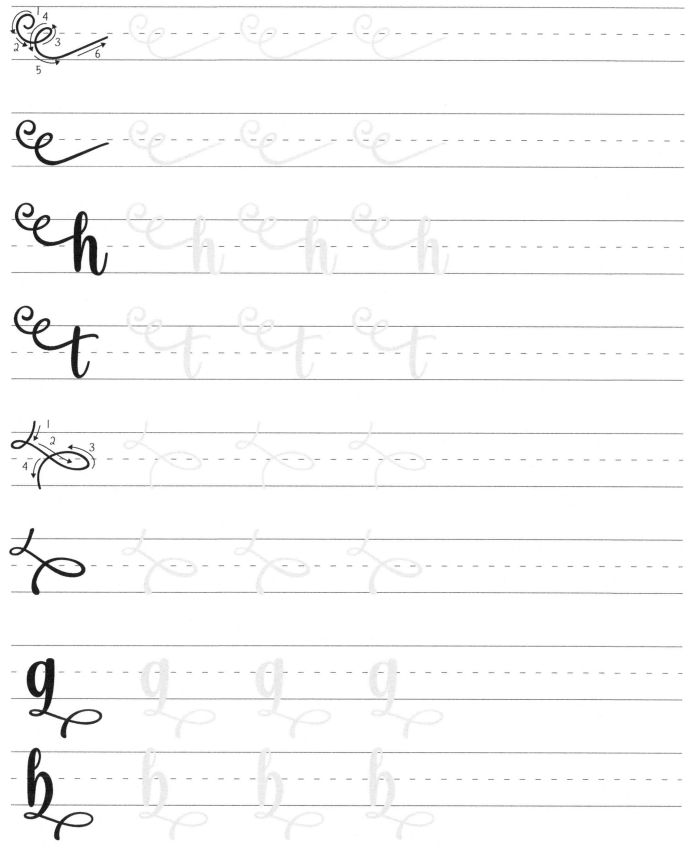

FLOURISHES

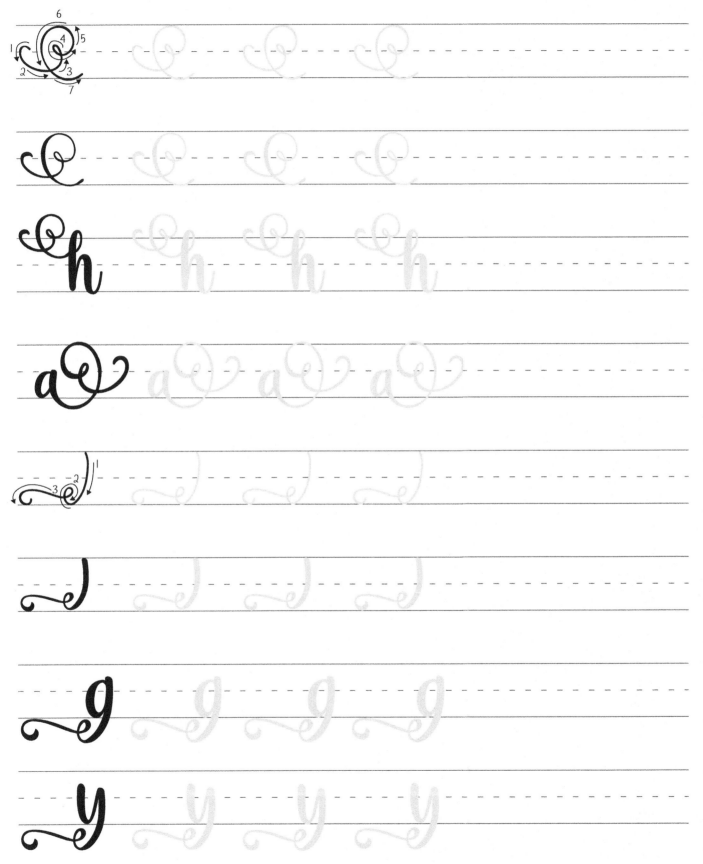

Sans Serif

Sans serif is a fun font to learn and a great addition to your skill set! You can vary everything about the letter--make it narrow or wide, tall or short--and have a different look every time. It's very minimal and neat, best used alongside other, more flowy styles to provide contrast. Sans serif looks very simple, straightforward, and bold.

Aa Bb Cc Dd Ee Ff
Gg Hh Ii Jj Kk Ll
Mm Nn Oo Pp Qq Rr
Ss Tt Uu Vv Ww Xx
Yy Zz

Sans serif can be done with almost any tool--anything that can give you a clean and consistent line is best. Pens and markers, as usual, are some of the most commonly used, but pencils, colored pencils, and crayons are great mediums, as well.

USE THE NEXT FEW PAGES TO PRACTICE YOUR SANS SERIF!

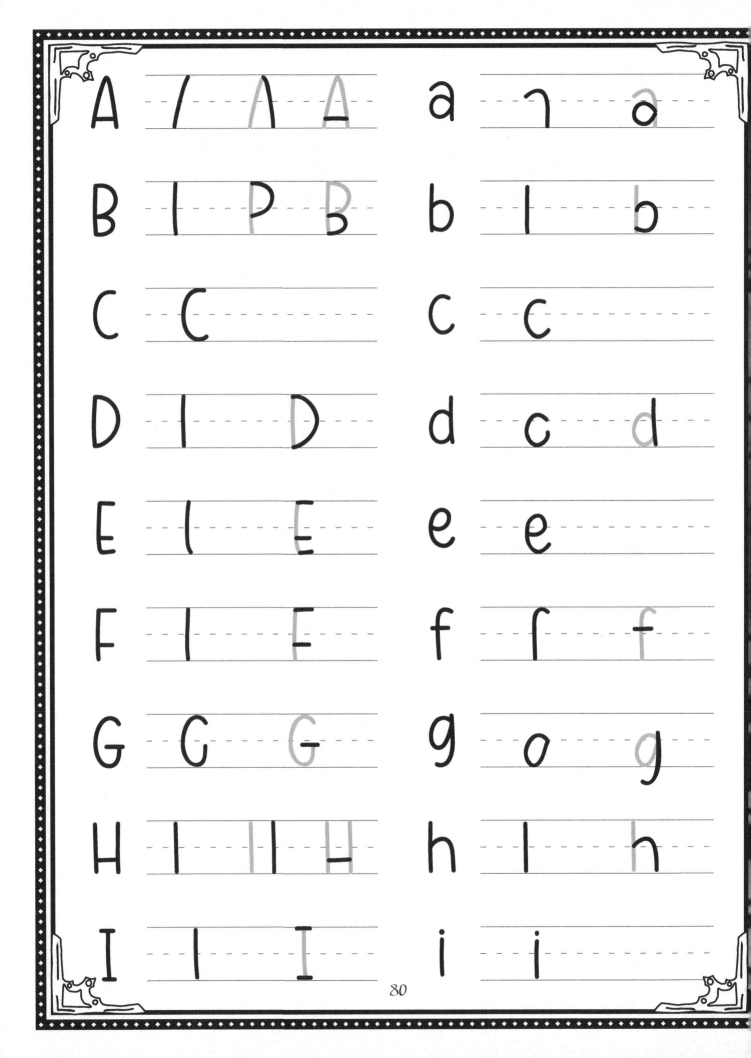

A / ∧ A a ⌐ ɑ

B | P B b | b

C C c c

D | D d c d

E | E e e

F | F f ⌐ f

G C G g o g

H | | H h | h

I | I i i

80

Aa Aa Aa

Bb Bb Bb

Cc Cc Cc

Dd Dd Dd

Ee Ee Ee

Ff Ff Ff

Gg Gg Gg

Hh Hh Hh

Ii Ii Ii

J J J J j j

K K ʏ K k l ʏ k

L L L L l l

M M ᴠ M m ɪ n m

N N ᴠ N n ɪ n

O O O o o

P P P p l P

Q O Q q c q

R P R r ɪ r

Jj Jj Jj

Kk Kk Kk

Ll Ll Ll

Mm Mm Mm

Nn Nn Nn

Oo Oo Oo

Pp Pp Pp

Qq Qq Qq

Rr Rr Rr

S S s s

T T T t t t

U U U u u

V V V v v v

W V W w v w

X X X x x x

Y Y Y y y y

Z Z Z z z z

Ss Ss Ss

Tt Tt Tt

Uu Uu Uu

Vv Vv Vv

Ww Ww Ww

Xx Xx Xx

Yy Yy Yy

Zz Zz Zz

PRACTICE HERE!

SERIF

Serif has the same basic building blocks as sans serif, but they can look very different. In serif, small strokes coming off the letter are added for more visual interest. Serif normally looks more like a typewriter font and is a bit more difficult than sans serif.

The tools best used are virtually the same as with sans serif. Pens and markers are excellent. Any tool that can be used with precision is the best, as this will help you achieve the right sizes and consistencies in the extra strokes.

Aa Bb Cc Dd Ee Ff
Gg Hh Ii Jj Kk Ll
Mm Nn Oo Pp Qq Rr
Ss Tt Uu Vv Ww Xx
Yy Zz

To draw serif, you're going to pull from a lot of skills you've already learned. Make sure you've mastered everything that's come before! Now, let's have a look at how to letter the alphabet, starting with a.

1. Start by writing your letter in a sans serif font. Keep it simple and monolined!

2. Add weight to the line at the bottom and thicken the downstrokes manually, just like in faux calligraphy.

3. On both sides of the bottom of the letter, add the extra strokes--the serifs.

4. Fill in the letter. You now have a serif a!

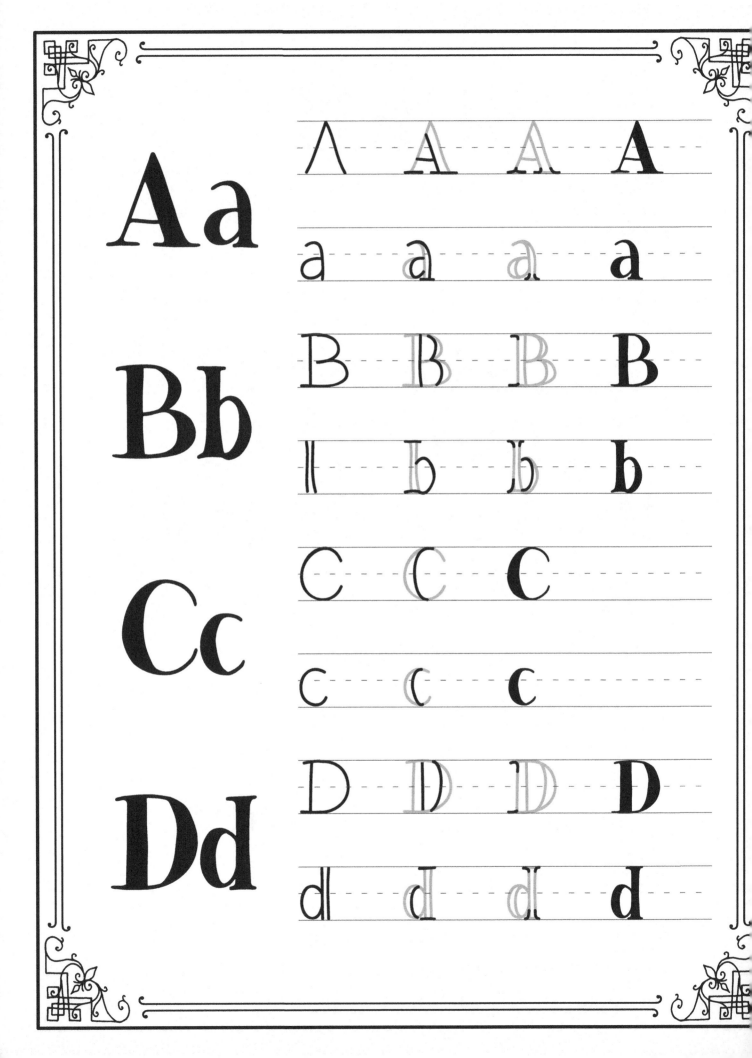

Aa Aa Aa Aa Aa Aa

Aa

Bb Bb Bb Bb Bb Bb

Bb

Cc Cc Cc Cc Cc Cc

Cc

Dd Dd Dd Dd Dd Dd

Dd

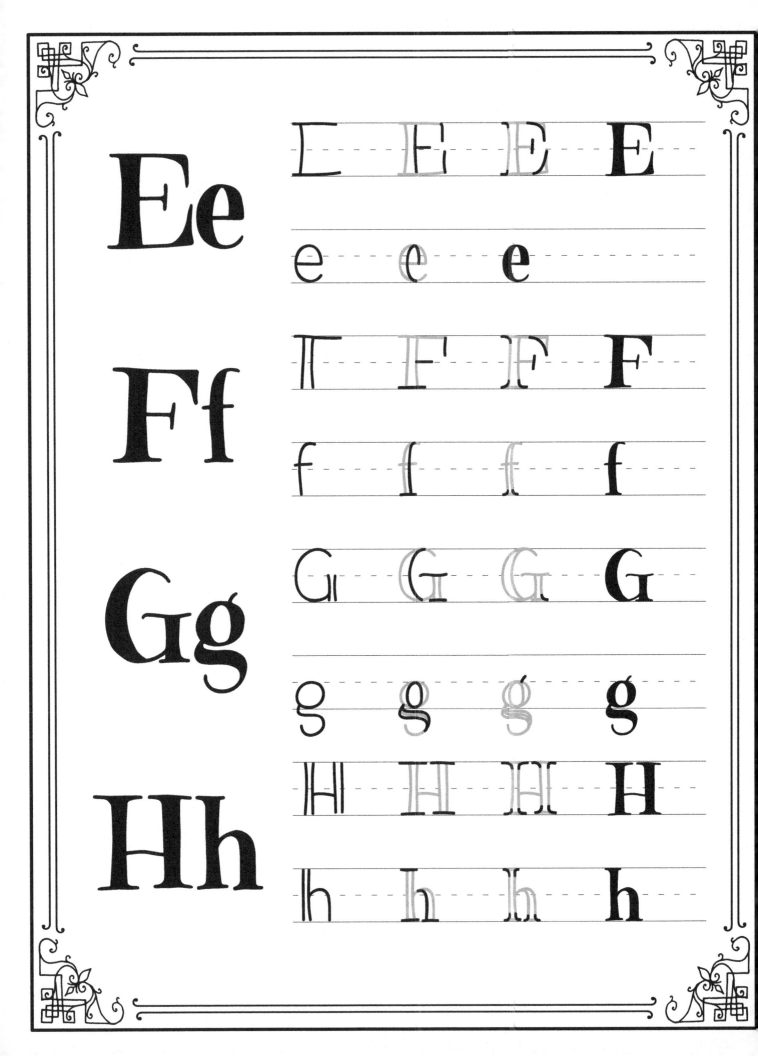

Ee

Ff

Gg

Hh

Ee Ee Ee Ee Ee Ee

Ee

Ff Ff Ff Ff Ff Ff Ff

Ff

Gg Gg Gg Gg Gg Gg

Gg

Hh Hh Hh Hh Hh Hh

Hh

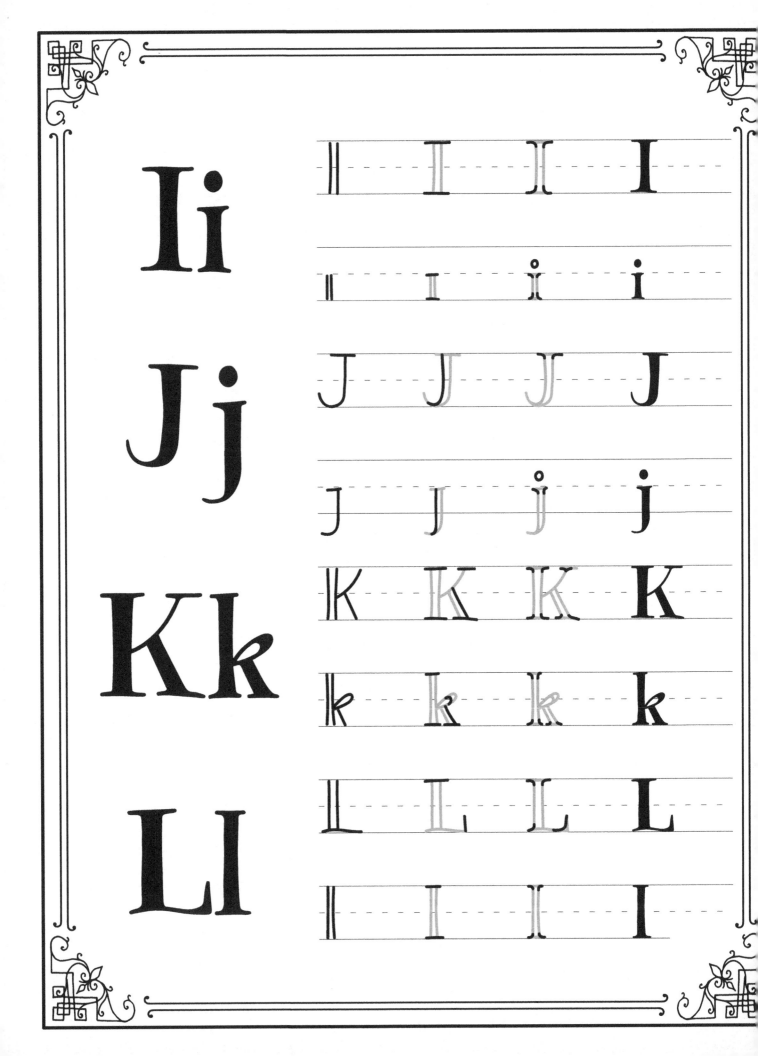

Ii

Jj

Kk

Ll

Ii Ii Ii Ii Ii Ii

Ii

Jj Jj Jj Jj Jj Jj

Jj

Kk Kk Kk Kk Kk Kk

Kk

Ll Ll Ll Ll Ll Ll

Ll

Mm

M M M **M**

m m m **m**

Nn

N N N **N**

n n n **n**

Oo

O O O **O**

o o o **o**

Pp

P P P **P**

p p p **p**

Mm Mm Mm Mm Mm

Mm

Nn Nn Nn Nn Nn Nn

Nn

Oo Oo Oo Oo Oo Oo

Oo

Pp Pp Pp Pp Pp Pp

Pp

Qq Qq Qq Qq Qq Qq

Qq

Rr Rr Rr Rr Rr Rr

Rr

Ss Ss Ss Ss Ss Ss

Ss

Tt Tt Tt Tt Tt Tt

Tt

Uu Uu Uu Uu Uu Uu

Uu

Vv Vv Vv Vv Vv Vv

Vv

Ww Ww Ww Ww Ww Ww

Ww

Xx Xx Xx Xx Xx Xx

Xx

Yy

Zz

Getting Creative

Serif is a highly customizable font, and there are a lot of different ways to make it unique. Here are just a few ways to vary the font!

Adding Curls

Aa Bb Cc Dd

Using Lines

Ee Ff Gg Hh

Drawing An Outline

Ii Jj Kk Ll

Adding Dots

Mm Nn Oo Pp

Composition

Composition is the combination of lettering with other elements to make a complete design. It involves a lot of planning and precision, so a ruler and pencil are good tools to keep nearby! Embellishments, blocking, and lettering styles all have a part to play here.

Composing your own lettering designs can be overwhelming and seem difficult as a beginner, but don't worry! There are no solid rules, and experimentation is highly encouraged. However, there are some guidelines that can help make your piece the best it can be! This section will walk you through those guidelines.

Combining Lettering Styles

When designing, you'll often use several different lettering styles to create more interest. There aren't any solid rules to this, but there are some things that can make it easier.

This might be difficult at first, but as you practice, it will become much easier. Stick to the general rule at first--no more than three styles in one design--but as you gain experience, feel free to disregard that rule!

When picking styles, go with your gut! Combine whatever feels right.

- Try combining opposite-looking styles, like faux calligraphy and serif.
- Try different varieties of lettering, adding curls, flourishes, and so on.
- Stick to a general theme at the beginning, like modern, casual, elegant, romantic, and so on. But as you gain experience, you can try mixing them!

How To Compose A Hand Lettering Design

When you start a design, use a pencil to experiment. Pick out the key words and draw them a few different ways, different sizes, different embellishments, and more! It's all about experimentation. Change as much as you want; there's no right or wrong way!

Blocking is part of composition and will be discussed later. Blocking is meant to help lay everything out in a balanced, satisfying way. You'll take a pencil and work out all the kinks in your design before drawing it with the more permanent tools.

Next up, we'll look at embellishments. These are easy ways to make your design even more beautiful! They're also great for filling space and adding balance.

EMBELLISHMENTS

Let's take a look at embellishments. The ones demonstrated here are by no means the only embellishments, but they're a good starting point!

FLORAL ELEMENTS

Let's start with the floral elements! They've been broken down into three easy steps to make it easier.

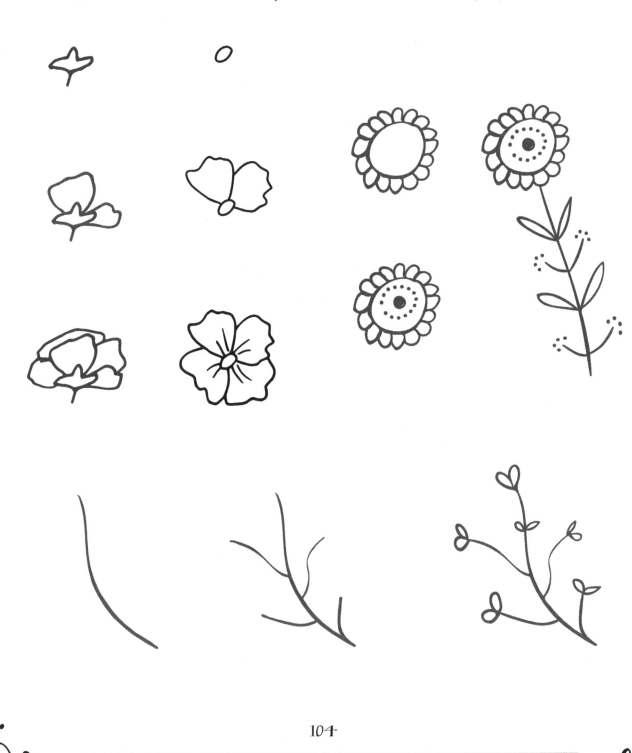

In need of more inspiration? Here are a few floral-inspired designs to get you started. You can use the three step principle to help--just observe what you'd like to draw and break it down into a few easier steps.

Use anything round to draw a circle and add the leaves around it!

BANNERS

Banners are another useful embellishment too! They're great for drawing around words you want to highlight or making a border for your design.

You can also add different details to your banner!

- Draw a basic banner.
- Add some shading lines. Keep them heavy in the ends and light in the banner itself. Make sure you only add lines to the edges of the banner, leaving the middle of the banner blank for letters!

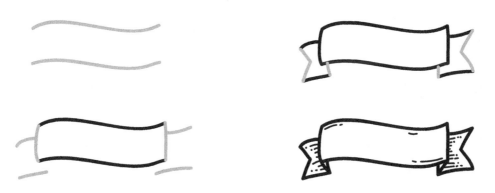

DIVIDERS

Another useful tool is dividers. They're used in designs to separate words or as borders. Here are some examples, but as always, feel free to invent your own!

OTHER SWIRLS AND ORNAMENTS

Additional swirls or ornaments are great for filling space in designs or balancing out your composition. Here are just a few!

BLOCKING

Now that you've learned every individual aspect of lettering, it's time to put it all together! This is where blocking comes in.

1 First, take the phrase you want to letter and find the important words. Try and find words that are especially meaningful to the phrase, as these will be the ones highlighted.

Happiness is not a destination, it's a way of life

2 Come up with a few different compositions by arranging the quote in different shapes, such as arches, bridges, or triangles. There are many more shapes you can play with! Take a look at the shapes below to get some ideas. You can try as many or as few possibilities as you like. Don't worry about making it look pretty or even--these are just getting ideas down!

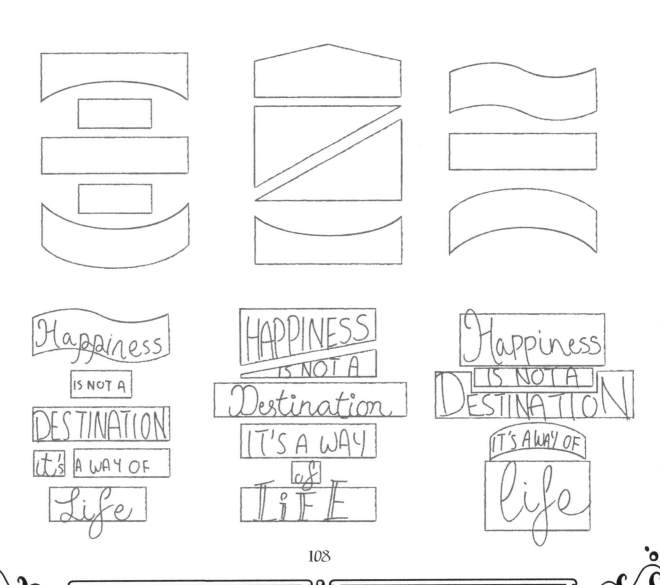

3 Once you've sketched some ideas, pick your favorite. Use a pencil, a ruler, and a new piece of paper to redraw it, making everything consistent and even. Add any guidelines you'd like--a centre guideline is especially helpful if you're centering letters. If you're aligning to the right or the left, add guidelines for that.

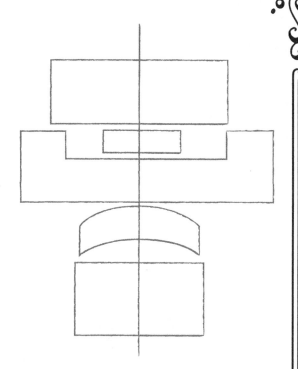

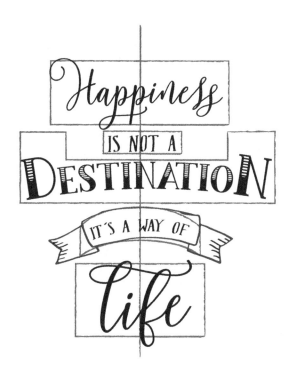

4 Letter the quote in the respective blocks with your preferred lettering style. You should also sketch your design in pencil first, as you might want to keep making changes until you have found your perfect design!

5 Add any embellishment or flourishes you'd like, and finish everything with your final tool. Erase any guidelines or pencil marks still visible. Now, celebrate! You have a complete design!

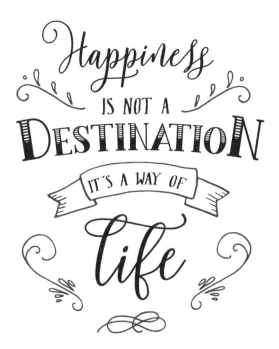

Twelve Day Lettering Challenge!

An important part of learning to hand letter is lots of practice. It can be difficult to keep going and come up with your own ideas, so this section is here to help you become even more familiar with all of the aspects of lettering.

Although it is a daily challenge, it is understandable that sometimes life gets in your way. If that happens, take it easy on yourself! You don't have to do the whole design in one day, but at least practice parts of it or write out the quote in just one particular lettering style. The most important thing is building up a habit of daily practice!

Every quote will have a complete design, a tracing guide, and space to draw it yourself. Some of the harder designs will also have extra tracing and practice area!

Day 1: Never Lose Hope

This is a fitting way to start off! Don't lose hope when practicing: you get better every time you put a pen to paper!

This quote will be done in faux calligraphy style, so a stiff pen or marker will be best. If you're feeling very confident, you could use a brush pen instead!

When lettering this, it will be easiest to draw the key words first, "never" and "hope."

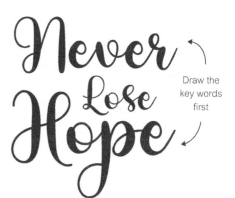

Draw the key words first

───── Trace The Design Here ─────

─────── Practice Again Here ! ───────

DAY 2: COUNT YOUR BLESSINGS

Today's quote will be done in brush lettering. With this design, notice the variations on the letters <u>C</u>ou<u>n</u>t you<u>r</u> <u>B</u>lessin<u>g</u>s. There's extra tracing and practice for these differences!

However, if you want to change it up, experiment! Pick out a different key word and try some variations to make it your own.

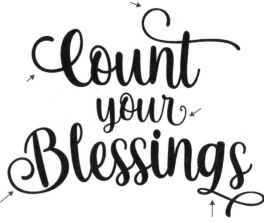

Take note of the variations where the arrows are pointing at!

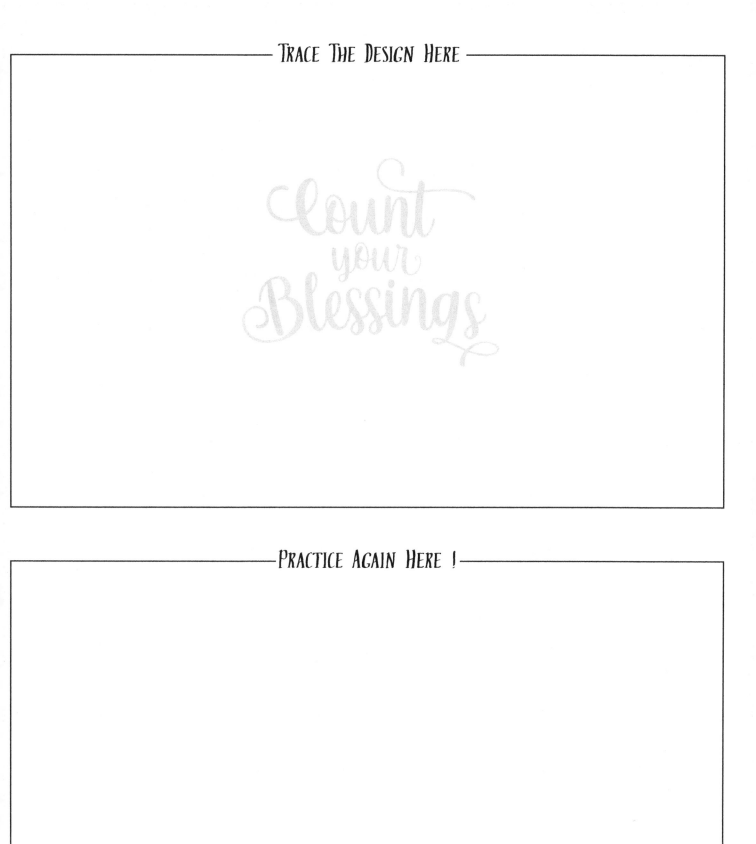

Day 3: Love Never Fails

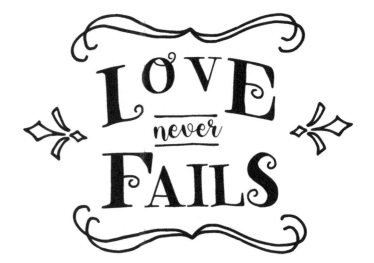

Today, we're using two styles: serif and faux calligraphy! Use a good pen or marker, and have a ruler nearby for drawing guidelines. Notice that the serif font has a slight variation, adding curls to parts of the letter. This design has some ornaments and swirls, but you can add any embellishments you'd like!

L L L L L

O O O O O

E E E E E

F F F F F

S S S S S

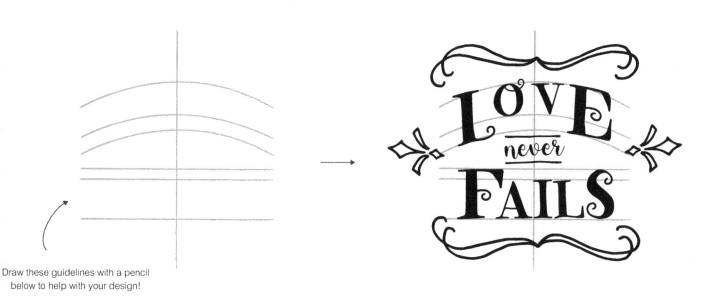

Draw these guidelines with a pencil
below to help with your design!

Day 4: Choose Kindness

The style of the day is monoline! Use a pen or marker that can give you a consistent line.

The design is fairly simple, but the extra flourishes can get tricky. Just keep practicing, and you'll get it in no time!

Day 5: Strive For Progress Not Perfection

Here's a wonderful reminder! This design combines sans serif and brush lettering, so you'll need good drawing tools like a pen and a brush pen. Today also includes a banner, so take some extra practice time with this design.

Strive for

PROGRESS

··· NOT ···

Perfection

— Trace The Design Here —

Strive for

PROGRESS

··· NOT ···

Perfection

— Practice Again Here ! —

Day 6: Have Courage & Be Kind

You're halfway done! Today's design can be done in either faux calligraphy or brush lettering, whichever you want to practice! If you'd like to practice both, place tracing paper on top of the pages and practice twice!

As always, use a pen or marker for faux calligraphy and a brush pen for brush lettering. When lettering this quote, draw the key words "courage" and "kind" first, and letter everything else around them.

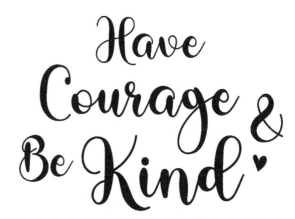

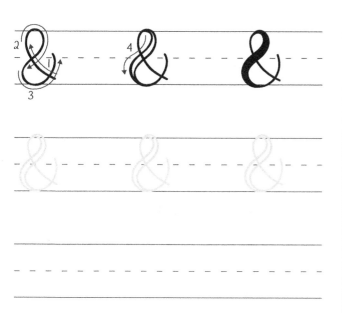

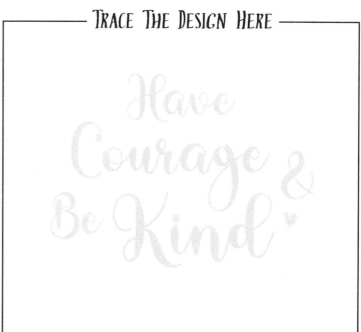

— Trace The Design Here —

— Practice Again Here ! —

Day 7: Happiness Is Homemade

Today's quote is mostly done in brush lettering with a small bit drawn in sans serif. A precise tool would be helpful for the embellishment banner! Notice the variation of the letters in Happiness Is Homemade.

Happiness
Is Homemade

Take note of the variations where the arrows are pointing at!

Trace The Design Here

Practice Again Here !

Day 8: Star Can't Shine Without Darkness

Today, you'll be lettering in serif and either faux calligraphy or brush lettering--it's up to you. Use pens or markers for the serif lettering and faux calligraphy and a brush pen if you want to brush letter. This design will be a bit more time-consuming, but it's well worth the effort! Take your time and enjoy the process.

Star can't SHINE ~without~ DARKNESS

Practice Again Here !

Trace The Design Here

Star can't SHINE ~without~ DARKNESS

Day 9: Enjoy The Little Things

You're in the final stretch of the challenge! This design is mostly done in faux calligraphy or brush lettering, with a small word in sans serif. Choose which style you want and use the appropriate tools. Swirls and leaves have been used to embellish this design, but feel free to use whatever you would like to spice it up!

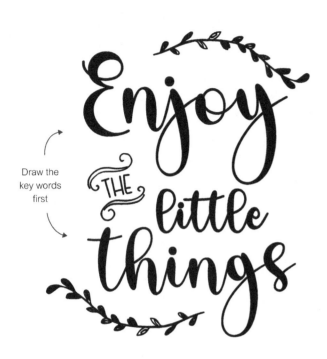

Draw the key words first

Practice Again Here !

Trace The Design Here

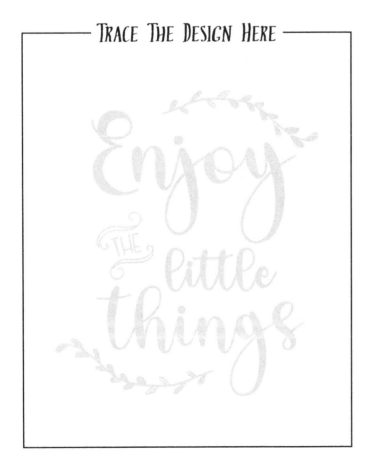

Day 10: Feel Your Soul

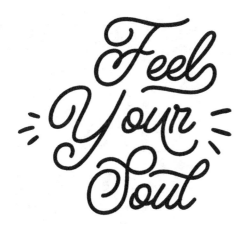

Monoline is the style of the day! Use a pen or a marker that creates clean lines. Today's quote is fairly simple, but pay attention to the more difficult variations of the letters Feel Your Soul.

Trace The Design Here

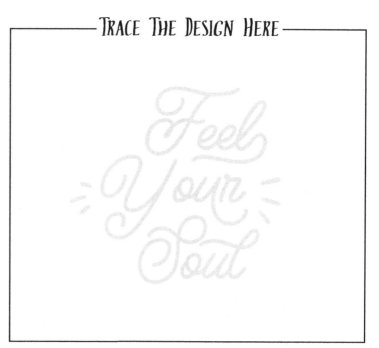

Practice Again Here !

Day 11: Laughter Is The Best Therapy

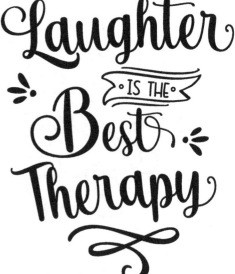

Today's quote combines san serif and brush lettering styles. Use the appropriate tools for each. Don't rush through this design; it has a lot of parts to it! Notice the banner, flourishes, and the letter variations in Laughter is the Best Therapy.

\mathcal{L}　　\mathcal{L}　　\mathcal{L}　　\mathcal{L}

\mathcal{is}　　\mathcal{is}　　\mathcal{is}　　\mathcal{is}

\mathcal{B}　　\mathcal{B}　　\mathcal{B}　　\mathcal{B}

Practice with monoline first then add line variations!

Laughter
· IS THE ·
Best
Therapy

Day 12: Dream Without Fear

Congratulations, you made it to the last day! One more quote, and you'll be well on your way to making your own designs.

The styles for this design are brush lettering and sans serif. For this design, drawing the decorative lines around the word "without" and adding everything else around that will be the easiest. Add whatever embellishments you'd like last!

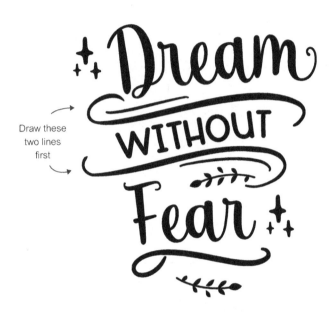

Draw these two lines first

── Trace The Design Here ──

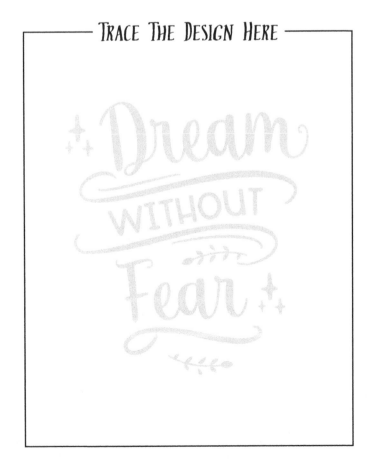

Bonus: Additional Practice Quotes

Congratulations for getting so far in your lettering journey! With some extra practice, you're well on your way to being a lettering pro. Here are some more quotes to try in your practice time!

Inspirational/Motivational

After every storm, there is a rainbow.

Life is a beach, enjoy the waves.

I see the magic in you.

Good things take time.

Sending a little sunshine.

Life is tough, but so are you.

Be the reason someone smiles today.

Throw kindness around like confetti.

Give yourself permission to rest.

Keep love in your heart.

You are capable of amazing things.

Friendship

Friends show their love in times of trouble,
not of happiness.

A friend is what the heart needs all the time.

True friends are always together in spirit.

A friend loves at all times.

Best friends until the end.

No matter when, no matter where, I'll always
be there.

Birthday

May your day be as wonderful as you.

Here's to another year of you.

Today is my favorite day of the year.

Funny

Always late but worth the wait.

Give me coffee and no one gets hurt.

Friends buy you food. Best friends eat your
food.

Bad ideas make the best stories.

Wake me up when there's coffee.

Napping is my cardio.

If only pizza was a health food.

Wedding

Be our guest.

And so, our adventure begins.

Born to love him/her.

It was always you.

We decided on forever.

Forever & always.

Christmas

Love will keep us warm.

Santa, please stop here.

Joy to the world.

All we need is love and Christmas spirit.

Let it snow.

No grinches allowed.

You can never have too many Christmas
cookies.

Made in the USA
Coppell, TX
28 January 2022